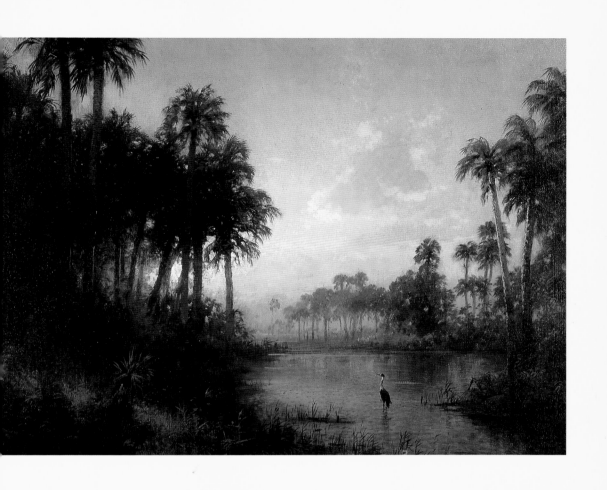

Florida Visionaries: 1870-1930

Cover: Herman Herzog
Landscape with Heron
Oil on canvas, 26″ × 34″
Dr. and Mrs. David A. Cofrin

University Presses of Florida
15 Northwest 15th Street
Gainesville, Florida 32603
Copyright© 1989 by the Board of Regents of the State of Florida
Printed in the U.S.A.
ISBN 0-8130-0929-4

This program is sponsored in part by Florida Arts Celebration, the Gallery Guild, the University of Florida, and Individual and Corporate Members of the Gallery Guild Curator's Circle.

Florida Arts Celebration,
the Gallery Guild, and
the University of Florida
Present

Florida Visionaries: 1870-1930

February 19–March 26, 1989

Introduction by
Ruth K. Beesch

Graduate Research Assistants
Carol Jentsch
E. Michael Whittington

Research Intern
Blair S. Sands

University Gallery
College of Fine Arts
University of Florida

759.13
U582f

ND
210
.F63
1989

Gallery Guild Curator's Circle

Florida Arts Celebration

Sun Bank of Gainesville
Gainesville Sun
Storter Printing
Barnett Bank
Merrill Lynch
Hunter/ESE Environmental Services, Inc.

Rod McGalliard
North Florida Regional Medical Center
First Union National Bank of Florida
Montague and Associates
Mr. and Mrs. James G. Richardson

Arch W. Roberts, Co.
Florida National Bank
Eastern Airlines
Mr. and Mrs. Sam T. Dell

Lars and Lynn Balck
Jack Busby's Design Cabinets
Mr. and Mrs. Allen DeLaney
Mr. and Mrs. Charles Denny III
Mr. and Mrs. Newton Ebaugh
Frame Factory and Gallery
Hadley Capital Management, Inc.
Lillians Music Store, Inc.
Mr. and Mrs. Ed Johnson
Dr. and Mrs. David A. Cofrin
Chris and Suzanne Beechler
Dr. and Mrs. Melvin L. Rubin
John and Margaret Sung
Ingley, Campbell, Moses, and Associates, Inc.

Anne Little
Thomas Feiber
Deirdre and Russ Fogler
Goerings' Book Center
Sam and Ina Gross
Mrs. R. L. Henderson
Roy Hunt
Mr. and Mrs. Joseph Little
Sally and Alan Merten
Paul West Ford
Perry Construction
Summerlin and Associates
Rick and Aase Thompson

Acknowledgments

An enormous amount of support and assistance was required to organize and produce an exhibition of this magnitude. From the beginning, the Gallery Guild enthusiastically sustained our efforts, and my appreciation is extended to Chairman Miriam Kimball and the Gallery Guild Board of Directors. The University of Florida and Provost Robert Bryan made initial and important commitments toward funding, as did the Florida Arts Celebration. Florida Visionaries Fundraising Chairman Caroline Richardson worked magic in our community by involving a variety of Corporate and Individual sponsors in our Curator's Circle. My special thanks to her and to Sally Merten, the members of our Curator's Circle, and Phyllis Bleiweis and Rod McGalliard of the Florida Arts Celebration.

A number of my colleagues extended their expertise to our curatorial effort. My thanks to Alan DuBois, Gary Libby, M. Barlow Pepin, Brucia Witthoft, Linda Ferber, Barbara Dayer Gallati, M. P. Naud, Warren Adelson, Martha Parrish, Robert Harper, Robbi and Sam Vickers, Sue Welsh Reed, Judy Larson, Budd Harris Bishop, and especially Robert Schlageter for their advice and assistance.

I am indebted to our lenders, both public and private, for their spirit of generosity. I would like to acknowledge the time they and their staffs have spent helping us to organize the myriad logistical details involved in an exhibition of this nature.

I would also like to thank graduate research assistants Carol Jentsch and Michael Whittington and research intern Blair Sands for the excellent entries they researched and wrote for this catalogue. It is a distinct pleasure to work with intelligent and diligent students who inspire such confidence.

At the University of Florida our program is continually sustained by President and Mrs. Marshall Criser, Provost and Mrs. Robert Bryan, and Dean and Mrs. Joseph Sabatella. The University Presses of Florida and John Knaub of the Office of Instructional Resources have provided excellent and professional guidance, as has our editor Myra Engelhardt.

As always, the staff of the University Gallery—Betsy Carlson, Michelle Roseland, Laura Namm, Chris Rabley, and Callie Neal—provide the behind-the-scenes support crucial to the success of such ventures.

A last tribute goes to my husband Bill, whose love, support, and good humor has enabled this effort.

Ruth K. Beesch
Acting Director
University Gallery

UNIVERSITY LIBRARIES
CARNEGIE MELLON UNIVERSITY
PITTSBURGH, PA 15213-3890

Lenders to the Exhibition

Gertrude J. and Robert T. Anderson
Albright-Knox Art Gallery
Anonymous Collection
Anonymous Florida Collection
The Art Complex Museum
The Brooklyn Museum
Cincinnati Art Museum
Cleveland Museum of Art
Dr. and Mrs. David A. Cofrin
Robert P. Coggins Collection of Southern American Art
The William Cope Family
The Cummer Gallery of Art
Elliott Galleries
The Henry M. Flagler Museum
Florida Gulf Coast Art Center
Nan and Roy Farrington Jones
Robert M. Hicklin, Jr., Inc.
The High Museum of Art
Hunter Museum of Art
Indianapolis Museum of Art
Lowe Art Museum, University of Miami
Memorial Art Gallery of the University of Rochester
The Charles Hosmer Morse Museum of American Art
Museum of Fine Arts, Boston
National Museum of American Art, Smithsonian Institution
The Parrish Art Museum
The Phillips Collection
Private Collection, New York
University Gallery, University of Florida

An Introduction to *Florida Visionaries: 1870–1930*

Ruth K. Beesch
Acting Director
University Gallery

During the early nineteenth century, American artists struggled to define their own significant form of artistic expression. While their European contemporaries were expected to depict events that alluded to allegory and formal history, American artists, lacking the elevated themes provided by mythology and literature, turned to the rugged and virgin territories and found in the American landscape their own noble traditions. By the 1840s the Hudson River School, best exemplified in its early years by the work of Thomas Cole, had developed a moralistic and spiritual vision which created from the landscape a subject as deeply rooted in idealized and mythic symbols as was painting in the European manner.

The Hudson River School espoused a philosophy of detailed observation balanced by harmonious composition. This philosophy also embraced the ideals of contemporary authors such as John Ruskin, Henry T. Tuckerman, and Ralph Waldo Emerson, who extolled Nature as the highest form of secular faith—a cosmological and timeless vehicle of sublime grandeur that manifested society's ideals (Novak 1980). By midcentury a slight but clear shift from the sublime to the naturalistic had occurred, heralding the late Hudson River School movement known as Luminism, in which the atmospheric effects of light and space were depicted in a poetic yet calm and measured manner. Large expanses of open sky and water and a horizontal extension of space identify the Luminist style.

Soon, Charles Darwin's *Origin of the Species* would minimize the moral significance of Nature and European contact would introduce the French Barbizon and Impressionist movements, lessening the American imperative for an indigenous artistic identity. ''God was replaced, in a sense, by 'style,' but a more limited Nature survived'' (Novak 1980: 11). However, manifest destiny prevailed, and artists of the mid- and late nineteenth century traveled extensively ''to partake of what both [Walt] Whitman and [Henry T.] Tuckerman defined as the 'zest' of adventure. Embodied here is the restless urge to conquer with the brush, the spirit of curiosity and exploration, the need to encounter God's virgin creation in nature, and the humbler, less grandiose intention simply to paint landscape with what Cole called a 'loving eye''' (Novak 1980: 10–11).

Late nineteenth-century Florida was among the many frontiers that inspired American artists. Lured to this tropical Eden of lush vegetation by the exotic climate, by travel and sporting literature, by a sense of isolation and solitude, and often by myths of rejuvenation fueled by failing health, a number of artists found in the Florida landscape imagery that was both beckoning and compelling.

That their perception of Florida was often romantic and visionary is not surprising when viewed and interpreted within the context of nineteenth-century American painting. What is intriguing is that the stylistic differences that developed from their individual representations of the Florida landscape contain so many complementary symbols and similar expressions that can still be recognized and understood by our generation, affected as we have been by the twentieth century. Florida's image was both created and

manifested by the work of the artists represented in this exhibition. The associations that grew from their vision of Florida as a tropical paradise are filled with illusions, both believable and ambiguous. This introduction and exhibition will explore and attempt to define the Florida work of these artists.

"[I]dyllic Florida…a land of sunshine and limitless opportunity" (Mackle 1977: 4); this description from *Florida for Tourists, Invalids, and Settlers,* published in 1882, was typical of the spirit of optimism that dominated late nineteenth-century thought. The era was one of boundless opportunity. Railroads were spanning the continent, quick communication was facilitated by the telegraph, and great personal fortunes were being amassed. In Florida, Henry M. Flagler, a partner with John D. Rockefeller in Standard Oil, opened the state to tourists by building a railroad that eventually extended as far south as Palm Beach and by constructing a series of grand resort hotels in St. Augustine and Palm Beach. From this time forward, Florida's image would be associated with oranges, tropical beaches, sunshine, palm trees, and the Fountain of Youth, and would be promoted through fiction, magazine articles and their accompanying illustrations, travel literature, advertisements and promotional materials, music, architecture, and paintings (Mackle 1977).

Frederick Edwin Church not only reinforced the concept of the American continent as a grand cosmic scheme, he led the way south into the tropics. The imagery of his South American scenes is one of idealized and metaphorical grandeur, a landscape imbued with an incredible and God-like presence. It was not this manifestation of the sublime that would represent Florida, however. Nineteenth-century literature and thought had translated a more transcendant sublimity from Edmund Burke's awesome sublime of the late eighteenth century. A mystical sublime, as defined by Ralph Waldo Emerson and Henry David Thoreau, revealed a profound sensitivity to the aesthetic of silence and simplicity (Novak 1976). When Florida's exotic but comfortable environment of swaying palm trees, balmy breezes, and tropical fruit was finally discovered, it fulfilled an essential image of Eden. Thus, it is suggested that Florida was often imagined and romanticized as a tropical arcadia, a premise that is supported by a range of visual imagery.

An early work by Louis Remy Mignot, dating from perhaps 1863, precedes the period represented in our exhibition by about seven years. In many ways, however, this painting defines the imagery that is central to our theme and that imparts continuity of expression to the diverse stylistic approaches of the artists represented. In *Sunset Landscape* the symbols are all in place. A dramatic sweep of atmospheric sky, glowing light, reflective water, romantic wildlife, and exotic foliage are all intensified to an ethereal effect. The scene embodies the concept of Florida as a natural paradise as early as 1863. Individual visionary imagination would both refine and heighten the essential symbols found in Mignot's *Sunset Landscape.* Stylistically this vision was represented in a variety of ways that will be explored in the following discussions.

The movement known as Luminism is embodied in the work of Martin Johnson Heade. Heade created numerous cosmic images of Florida that reflect a perception of certain atmospheric qualities and their ability to determine mood. Frequently these works depict a distant and pastoral utopia where cattle graze bathed in softly glowing light. These Luminist works rely on a horizontal format that opens the foreground like a stage, upon which characters such as lilypads, birds, cattle, tranquil water, and the oft repeated twisted and gnarled branch, are set. Both George Herbert McCord and George Cope expand upon the concept of Luminism (although technically they do not fall within the confines of the movement) by including an imaginary and magical aura in their work. McCord embraces light with an almost religious ecstasy. His *Florida Sunrise* is a fantasy

landscape in which water, wildlife, and foliage glisten in magnificent homage. In contrast, Cope's Florida scenes are personal and mystical images, which emit rather than reflect radiant light.

By the end of the Civil War the Hudson River School style of painting was in decline. The stylistic changes found in the work of George Inness, recognized during the era as one of America's foremost landscape painters, provide evidence of the demise of this indigenous American movement. Even in his formative years Inness never sought to imitate the grand and moralistic style of Thomas Cole; rather he drew from such classical sources as seventeenth-century European landscape painting. Inness's panoramic treatment of the American landscape and his early concern for detail were, however, influenced by the Hudson River School. Soon the influence of the French Barbizon movement would loosen his brushwork and affect his perception of light and color. In his later years Inness subscribed to the religious and philosophical doctrine of Emanuel Swedenborg, who espoused a parallel world, not unlike earth, in which time and space are variables, and all life is divine presence. Inness, like many of his contemporaries, had moved away from an idealized romantic vision to a personal and spiritual vision that is obvious in his Florida scenes.

Although the era of the sublime American landscape was waning, the post-Civil War period supported proponents of manifest destiny, among them the artist Thomas Moran, whose reputation was firmly established by a grand series of paintings of the American West. At their simplest, Moran's visions of Florida offer quintessential views of the landscape, often caught during nature's grandest moments. At their most complex, Moran's Florida scenes, rendered in a skillful, realistic style in his studio from sketches he made on site, are romantic and fanciful portrayals of imaginary narratives. These make full use of a variety of symbols, from the exotic cast of characters illustrated in a number of Fort George Island scenes to the atmospheric sky and water. The paintings of Louis Comfort Tiffany embody a similar spirit of magical narrative. Tiffany, like Moran, traveled extensively. Tiffany, however, ventured east, drawn by the light and architecture of the Middle East and North Africa. His paintings evoke atmosphere, from the dense and threatening effect of *St. Augustine* to the clarity of light and space of his North Africa scenes.

A number of European styles were introduced to American artists who traveled abroad, and by the mid-nineteenth century artists such as William Morris Hunt were returning to America with new philosophies and techniques. Hunt's values, garnered through his study of the French Barbizon movement, were those of the simple life—hard work, essential truths, and rural beauty. Along with direct observation, and honest and noble forms of expression, Hunt also adopted the loose and sketch-like quality of the Barbizon movement in his paintings. American interest in the Barbizon movement grew slowly, reaching a zenith in the last decade of the nineteenth century and influencing the work of numerous American painters for two decades before this. Hunt's vision of Florida is poetic and tranquil, capturing an image of brooding serenity. Like William Morris Hunt, Herman Herzog brought to Florida an eye influenced by European style. Herzog was trained at the Düsseldorf Academy, where the style of German landscape painting was similar to that of the Hudson River School as American and German artists shared a similar sense of national pride in the beauty of their native scenery. In contrast to the Barbizon style, the Düsseldorf Academy concentrated on sharply focused realism and a clarity of spacial continuity. Herzog visited Florida between 1885 and 1910, and by this time his style had softened, perhaps influenced by the Barbizon movement. His works from this period, while often sentimental, offer Florida's unspoiled beauty with an uncompromised vision.

Both James Wells Champney and Frank Taylor captured Florida with an essentially illustrative intent. They successfully succeeded in creating two separate series of brush and pencil drawings that depict the state as a tropical paradise, while realistically portraying late nineteenth-century Florida. These works, typical of this period before the phenomenon of journalistic photography, fed a demanding public with visual information and created a stylistic approach that was, by necessity, often factual and detail-oriented. That both Taylor and Champney contributed to Florida's created image during this era through the subsequent publication of their work does not detract from the visionary quality of their art. The essence of their expression is easily interpreted within the context of this exhibition and is a tribute to the imagery they so eloquently created.

A provincial quality is inherent in the realism of the works of George Smillie, William Aiken Walker, and Stephen J. Parrish. Smillie's scenes of St. Augustine are neatly rendered in a nostalgic manner that recalls this historic period quite accurately. Walker spent many years observing the Florida coast and reveling in the state's bountiful fishing and natural beauty. His work is often simple in composition and content, relying on a few simple buildings or a shoreline to impart theme. In *Breakers in Florida* he enhances a simple horizon of water and sky, breaking the scene just slightly with a line of waves and clumps of vegetation. Parrish follows in this realist tradition of quiet and simplicity, creating mood through the expressive delineation of foliage, sky, and water.

Individual style is an obvious quality in the work of two great American artists, Winslow Homer and John Singer Sargent. With an incredibly successful career as a society portrait painter mostly behind him, Sargent sought in his later years to pursue his own intuitive directions. A trip to Florida in 1917 provided him with a rich variety of imagery that resulted in a series of watercolors that are startling in their unconventional and modern qualities. An intriguing perception of reality that is enhanced by his dexterous and often modernistic handling of the watercolor illuminates these works. Sargent was hardly within the tradition of American landscape painting of the nineteenth century; however, in these scenes we again find evidence of numerous complementary symbols and imagery consistent with that of his contemporaries. Winslow Homer's career spans a variety of thematic changes that bear close scrutiny, for his work is stylistically so individual. After an early career as an illustrator, Homer, in his paintings, dwells on scenes of youth and bucolic happiness. Later he enters a period that pits man against the various elements of nature, and still later he returns to a more serene vision of man within nature. Each of Homer's trips to Florida produced a group of watercolors as diverse as the places he visited, and these works reflect the sense of calm found in his later images. Homer's fascination with certain Florida motifs is observable in his choice of imagery. He almost always manipulates the scene, heightening its emotional impact by placing himself and the viewer in close proximity to his subject. Barbara Novak (1979) points out that Winslow Homer expressed a fascination for the single moment that yields not evanescent but eternal content. In his Florida watercolors we perceive a unique and individual image of reality. Individual style, romantically depicted, best describes the watercolors of Granville Perkins. Perkins's manipulation of watercolor is rich and modernistic.

Like previous European movements, Impressionism and Post-Impressionism would affect American artists. Frank Weston Benson was influenced not only by Impressionism, but also by eighteenth-century Japanese ink paintings. His flowing scenes of wildlife are rendered with a confidence of handling and style that appear effortless. Henry Salem Hubbell was also influenced by Impressionism as well as by the works of Velazquez and Whistler. Primarily a portrait painter, Hubbell ably adds exotic foliage to his *Portrait of Rose*

Strong Hubbell, and, while he, like Sargent, does not belong within the mainstream of nineteenth-century landscape painting, this romantic vision is hard to resist.

Florida's image in paintings by this group of artists went beyond the merely representational. Heightened by imagination, myth, mysticism, romance, and poetic tranquility, and influenced by attitudes, beliefs and yearnings, this era was inspired by a created image of reality that was truly visionary.

Bibliography

Mackle, Elliott James, Jr.,
 1977 "The Eden of the South: Florida's Image in American Travel Literature and Painting." Doctoral dissertation. Atlanta, Georgia: Emory University.

Novak, Barbara
 1976 "On Divers Themes from Nature." *The Natural Paradise: Painting in America, 1800–1950,* edited by Kynaston McShine. New York: The Museum of Modern Art.

 1979 *American Painting of the Nineteenth Century.* 2nd Ed. New York: Harper and Row.

 1980 *Nature and Culture: American Landscape and Painting, 1825–1875.* New York: Oxford University Press.

Martin Johnson Heade (1819–1904)

Martin Johnson Heade (in 1846, he changed the spelling from the original Heed) was born in Lumberville, Pennsylvania, on August 11, 1819. While still a young man, Heade decided to become a painter and began to study with Edward Hicks, a Quaker coach- and sign-painter known principally for his series, *The Peaceable Kingdom*. In 1840–41, ''Johnson,'' as he was known, traveled to Italy, France, and England. Upon his return to America in 1841, Heade had his first exhibition in which he showed *Portrait of a Little Girl* at Philadelphia's prestigious Pennsylvania Academy of Fine Arts. From this time until the 1880s, Heade was often on the move, changing residences frequently and traveling in Europe and America. By the 1840s, he had acquired an interest in landscape painting. His tours throughout New England in the 1850s were recorded in his first dated landscape, *Rocks by New England* (1855). The year 1859 was important for Heade: he painted his first Luminist work, *Rhode Island Landscape;* moved to a more permanent studio in the art center of New York City; and met Frederick Edwin Church, who influenced his work and later became a close friend.

Heade's work began to mature after his move to New York, perhaps as a result of his steady contact with other artists. Heade made the first of three journeys to South America in late 1863–64, lived in London in 1865, and, during the 1860s and '70s, traveled to Colombia, Panama, and Jamaica, where he was inspired to paint his orchid series. The artist made several trips in North America during the 1870s—to California and British Columbia in the west and around the northeast. After visiting Florida in 1883, Heade married Elizabeth Smith and moved to St. Augustine in 1884 to live permanently. In this antique city, Heade met Henry Morrison Flagler, who became his first major patron. Flagler built several artists' studios behind his grand new Ponce de Leon Hotel, and Heade and other painters were soon established as artists-in-residence. Heade painted Florida landscapes but turned more often to still life flower painting in the 1890s. He had completed two paintings some months before his death on September 4, 1904.

Like many other adventurers of his era, Martin Heade first came to Florida in search of a new Eden. Although he was initially disappointed that the hunting and fishing were more difficult than he had been promised, he soon found in Florida's Edenic atmosphere a land rich in flora and fauna. Finally a truly respected and even admired painter, Heade enjoyed the social life of a well-patronized artist as much as he did the serenity and peace he found in the somewhat ''uncivilized'' side of Florida. He chose to paint only the untouched parts of the land, although he often added grazing cattle to lend a pastoral quality to his work. In *Tropical Marshes* (c. 1880), Heade wanted a horizontal format broader than his usual canvas proportions of width twice the height and chose instead a canvas whose width was three times its height. In this way he was better able to capture the flat, wide-open character of the Florida land. His ''torpedo clouds'' (Stebbins 1975: 159) extend across the entire surface to emphasize the extreme breadth of the work. The painting is so realistically rendered that the viewer seems able to step right into the landscape and dabble his toes in the pond. Here, Heade combined many details seen in his other works to create a more decorative image: lilypads are artfully scattered across the water, a gnarled branch is placed in the foreground center, and sabal palms bend gracefully toward a small group of cattle in the distance. This theme, the serenity of plants and animals in peaceful coexistence, is one that Heade and many artists of the time returned to often.

The concepts of Luminist painting are grounded in a variety of philosophical notions of spirituality, morality, and nature's role in art and life. ''Nature in luminist painting seems suspended in a state of being rather than becoming'' in the words of American art

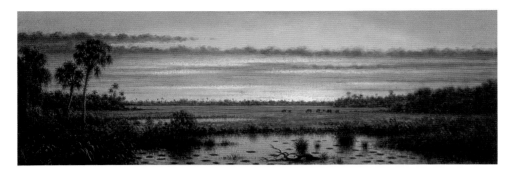

Martin Johnson Heade
Tropical Marshes, c. 1880
Oil on canvas, 12^{1}/$_{4}$″ x 36^{3}/$_{4}$″
The Charles Hosmer Morse Museum of American Art, Winter Park, Florida, through
 the courtesy of the Charles Hosmer Morse Foundation

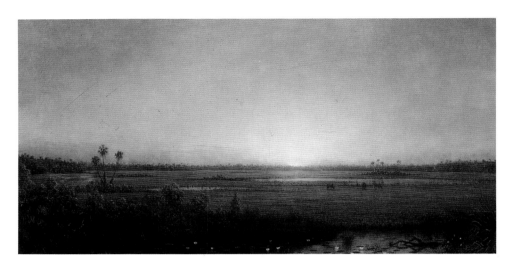

Martin Johnson Heade
Twilight, c. 1886
Oil on canvas, 28" x 54"
The High Museum of Art, Atlanta Georgia
Gift in memory of Howard R. Peevy from his wife

historian Barbara Novak (Novak and Ellis 1986: 29). Heade's *Twilight* (c. 1886) is no exception to this maxim. The mystical mood of this green-blue painting seems to express the ideas about man, nature, and spirit prevalent during the nineteenth century. The transcendental sense of calm combines with the image of a utopian world to culminate in the immense glowing cloud of light that arises in the background. The land appears pristine, untouched by the hands of corrupt man, an image of eternal beauty and peace. The innocent animals graze quietly in the middle ground and, with the flat pools of water and motionless trees, represent a timeless environment of pure, unadulterated nature.

As Heade learned to paint the new tropical landscapes, he often experimented with color in order to attain the dramatic heights of his northern marsh paintings. He sometimes broke away from his characteristic sunset shades to work in the moodier hues of navy blue and emerald green and variations of these cool tones. Despite the apparent "empty" canvas, *Twilight* is alive with tiny detail from the twinkling white water lilies floating on the dark pond to the carefully painted frame of tall grasses on both sides. Here, Heade is a master of the understated painting imbued with the sweet melancholy of solitude and silence.

Heade worked both as a landscape and a still life painter, which was somewhat unusual in the nineteenth century. The latter genre was not held in high esteem, but Heade was able to give his flower paintings a subtle mysticism that intrigued and seduced viewers. By the 1890s, Heade had been painting flowers for thirty years, but it was in this, his penultimate decade of life, that he seemed to gather up all the experience of his artistic career to create an exceptional group of flower paintings. In *Four Cherokee Roses* (c. 1885–95), Heade used the horizontal format because this "reclining" position better enhanced the Florida flowers. The composition also changed from an earlier triangular one to this

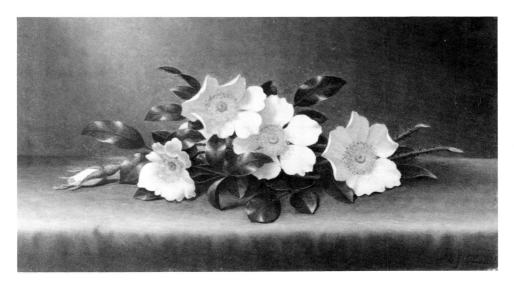

Martin Johnson Heade
Four Cherokee Roses, c. 1885–95
Oil on canvas, 9¹/₂″ x 18″
The Henry M. Flagler Museum, Palm Beach, Florida

more interesting, asymmetrical structure. The overlapping petals add a certain haphazard quality to the arrangement. Heade always thoughtfully planned his compositions, however, and though he may have painted some studies of these flowers *en plein air,* he invariably erased all impressionistic touches from his works. Instead, Heade employed Luminist concepts to display his close observation of the effects of light on objects, creating a scene that is intensely realistic with all signs of the brushstrokes removed. In this simple but evocative work, the dark green leaves shine against the background, while the smooth, cool quality of their surfaces becomes apparent against the soft, downy textures of the pure white petals.

Heade's still life subjects ranged from native Florida orange blossoms and Cherokee roses to red roses, Egyptian lotus blossoms, and, finally, his magnolia series. Heade's primary biographer, Theodore E. Stebbins, Jr. (1975: 172), calls the magnolia paintings, ''the finest expression of the artist's late years: they are private statements which also tell the story of Victorian taste and ethics.'' In his early versions of this subject, Heade used a vertical arrangement as seen in *Magnolia in an Opalescent Vase* (c. 1885–95). He concentrated equally on capturing the essence of the magnificent opening blossom and on accurately rendering the delicate vase and shimmering yellow velvet cloth that offset the creamy flower and waxy green leaves. In keeping with his love for carefully designed compositions, Heade leaned the magnolia to the left so that it would continue the flowing line of the leafy decoration on the vase below. Sumptuous ornamentation and flower symbolism were two popular themes in Victorian-era painting. Though the magnolia represented love of nature and magnificence in the nineteenth-century lexicon, the feelings underlying Heade's magnolias seem to relate to femininity and sexuality. Stebbins (1975: 176) connects these newly expressed emotions to Heade's then relatively recent

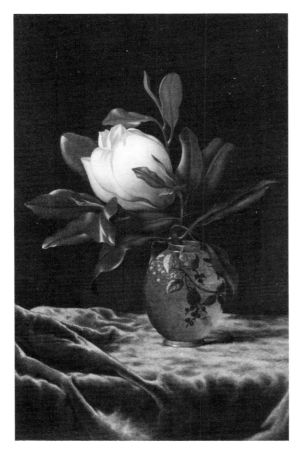

Martin Johnson Heade
Magnolia in an Opalescent Vase, c. 1885–95
Oil on canvas, 15$^{1}/_{8}$″ x 24$^{1}/_{8}$″
The Henry M. Flagler Museum, Palm Beach, Florida

first marriage and writes, ''For Heade, the flower always represented woman.'' The large blossom in the delicate glass vase seems top-heavy, as if it may fall over at any moment, adding a sense of subtle uncertainty and tension which, combined with the striking effect of the lush yet refined image, beckon the viewer to look again.

By the 1890s, Heade had learned to paint Florida scenery with deft and graceful handling of form and color. He returned to the larger canvases of his earlier seascape period but also worked often in a small format. In *St. Johns River* (c. 1890–1900), Heade once again emphasized the broad panorama of the Florida landscape. The subject is a large pool of water framed by a stand of moss-draped trees on the near right and another stand of trees on the left. Behind the reflections of the still water, a wide expanse of sawgrass spreads into the distance where a line of dense brush and more palm trees mark the

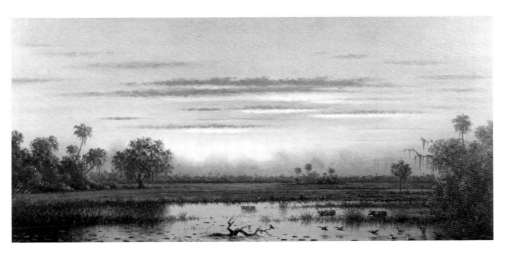

Martin Johnson Heade
St. Johns River, c. 1890–1900
Oil on canvas, 13" x 26"
The Cummer Gallery of Art, Jacksonville, Florida

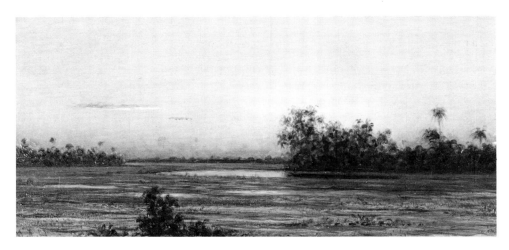

Martin Johnson Heade
Sunset: A Florida Marsh, n.d.
Oil on panel, 6" x 12¹/₈"
The Parrish Art Museum, Southampton, New York
Clark Collection

horizon. The long, flat horizontal clouds above echo and balance the measured planar movement from foreground to background of the lower extreme. The twisted form of a branch emerging from the water has the same eerie quality as a similar branch in *Tropical Marshes.* In *St. Johns River* the artist uses subtle, complex color gradations of pink and lavender tones tinged with delicate accents of golden peach. Only in the deeper shadows among the trees at the top right edge does Heade allow a rich plum to enter the frame. The limited palette lends the painting a more profound feeling, as if we have been privileged with a rare glimpse of a natural paradise, simple and pure, rather than overwhelmed by a didactic depiction of glorious Nature.

Heade made a lasting impression on the history of American landscape art with his unique scenes of marshes. He painted more than one hundred versions of this subject, ranging from the salt marshes of the eastern United States to the swamplands of northern Florida. In his well-known series of marshes near Newburyport, Massachusetts, Heade emphasized the transitory nature of light and its atmospheric effects. In these works, the artist demonstrated Luminist concepts—strong horizontal composition, carefully measured movement plane by plane into the distance, and glowing light—with greatest commercial success, both in his own time and in the years since 1940 when he was rediscovered. In *Sunset: A Florida Marsh* (n.d.), pools of water stretch across the picture plane from the near foreground to the distant horizon. The viewer's eyes wander from side to side, tracing the patterns of shining water, until they reach the misty line where the sky meets land. In this ambiguous space that is a transcendent mix of solid earth and airy atmosphere, one becomes, in Thoreau's words, "dissolved in the haze" (Novak and Ellis 1986: 29). Heade celebrated the beauty in the fertile land of Florida with its abundance of water and greenery. He knew that the simplicity of this free and open composition would appeal to the mind as well as to the spirit of the viewer.

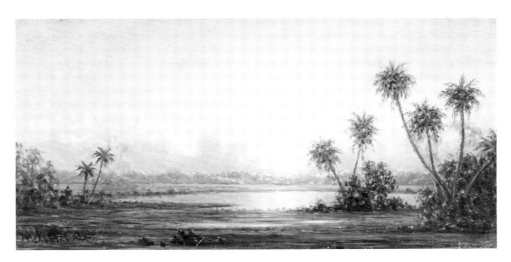

Martin Johnson Heade
Florida Sunset, with Palm Trees, n.d.
Oil on academy board, 6" x 12"
The Parrish Art Museum, Southampton, New York
Littlejohn Collection

In his first Florida paintings, Heade tried to emulate the style of his earlier marsh works by simply replacing the northern haystacks and twisting rivers with southern palm trees and "a series of puddles, lakes, and ponds" (Stebbins 1975: 159). In their extreme horizontality, some of these paintings of wide open, empty spaces, do retain a "sense of barrenness" (Stebbins 1975: 161) but most often to their virtue. They seem to reflect the freer air of Heade's Florida, not yet clogged by too many people and too much civilization. Heade did attempt to offset this austerity in other works beginning in the late 1880s. In *Florida Sunset, with Palm Trees* (n.d.), he placed the dark, spidery outlines of the palms against the radiant sky in the right foreground and further back on the left. The position of the trees and the winding pool of water lead the eye in a reverse S-shape to the billowing clouds and low-lying mass of foliage in the background. The tree trunks trace a distinctive vertical pattern that adds pictorial energy to the otherwise static and horizontal structure. This landscape bears no trace of humanity; it is a vision without specific reference to time or place. Heade's nearly centered broad patch of sun on the lake and the slight haziness in the air created by his looser brushstrokes add an ethereal quality that complements the poetic nature of the scene.

C.J.

Bibliography
Novak, Barbara, and Ellis, Elizabeth Garrity, eds.
　1986 *Nineteenth-Century American Painting.* New York: The Vendome Press.
Schlageter, Robert W., ed.
　1981 *Martin Johnson Heade.* Jacksonville, Florida: Cummer Gallery of Art.
Stebbins, Theodore E., Jr.
　1975 *The Life and Works of Martin Johnson Heade.* New Haven: Yale University Press.

George Inness (1825–1894)

Born in Newburgh, New York, in 1825, to a prosperous mercantile family, George Inness was the fifth of thirteen children. It would be sixty-five years before he would make the first of four winter trips to Florida's remote landscape. By this time, Inness's paintings were selling well, and he had achieved a good measure of fame.

Inness showed an early propensity for art. Nevertheless, his father did what he had done for all of his sons and set George up in the grocery business. Only a month had passed before the fourteen-year-old grocer, with paint supplies in hand, walked out of the store and locked the door behind him to pursue a life in art. George's father finally arranged drawing lessons for him with a local painter, John Jesse Barker, who soon confessed that his student was more adept than he. At sixteen, Inness began to study engraving with the map engravers Sherman and Smith of New York. A year later, he received his only formal instruction, from the French landscape painter Regis Gignoux.

By the time Inness was in his early twenties, he had sold paintings to the American Art Union and exhibited at the National Academy of Design. A wealthy New Yorker, Ogden Haggerty, came across Inness painting in a park and became his patron. In 1850, after Inness had married his wife Elizabeth, Haggerty sent them to Italy for nearly two years and, on their return, to France, where Inness was influenced by the spirit of the French Barbizon painters. An ardent abolitionist, Inness tried to enroll in the Union Army when he returned from Europe but was rejected. Inness was sickly all of his life and suffered from what he called a "fearsome disease," epilepsy (Schlageter 1980: 7).

From 1863 to 1867, Inness resided at Eagleswood Military Academy in New Jersey, where Marcus Spring offered him a house in exchange for what would be one of Inness's masterpieces, *Peace and Plenty*. It was at Eagleswood that Inness met fellow painter William Page, took as his pupil Louis Comfort Tiffany, and explored various religious philosophies. William Page introduced Inness to the teachings of Emanuel Swedenborg, who believed there existed an invisible spiritual world fundamentally different from yet resembling the world perceived by the senses. By the late 1870s, Inness's interest in Swedenborgism became all-consuming, influencing his later work (Mackle 1977).

Inness made his third trip to Europe in 1871 to supply his Boston dealers with marketable landscapes. By 1878 the artist had settled with his family in Montclair, New Jersey, and it would be these years before his death in 1894 that would bring George Inness to Florida and reward him with the recognition and financial security he had earned. It is difficult to document definitively George Inness's trips to Florida through his work. Because this artist felt that his signature was not important and that a painting should stand on its own merit, his works were often signed, dated, and titled by others. Inness's personal correspondence indicates that the artist visited Florida in the winter months (January and February) between 1890 and 1894, during which time he kept a house and studio in Tarpon Springs near the Gulf Coast.

Whether Inness came to Florida for its untouched environment or to recuperate from poor health is unknown. It is known, however, that Inness, unlike his contemporaries, preferred sites that did not lend themselves to the dramatic. Rather, he created mood through his visionary interpretation of such subtle settings as a bit of marshland in *Home of the Heron* (1893), a small expanse of meadowland with two modest buildings in *Eventide, Tarpon Springs, Florida* (1893), and a small section of forest interior in *The Road, Tarpon Springs, Florida*, or *Moonlight* (1893). Abraham A. Davis (1978: 119) describes Inness's works in the following way: "The lack of dramatic emphasis within the scene and the self-immersion of the figures contribute to a mood of quietness; the grey-hued tonality and the all-enveloping mist endow the quietness with a strange remoteness."

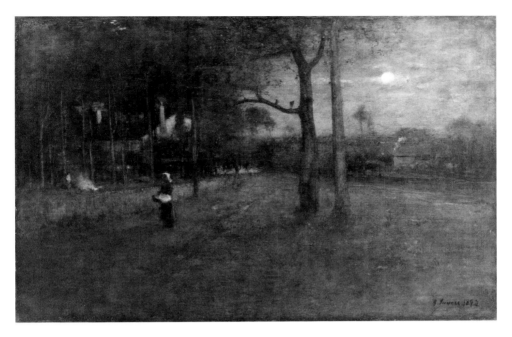

George Inness
Moonlight, Tarpon Springs, Florida, 1892
Oil on canvas, 30″ x 45″
The Phillips Collection, Washington, D.C.

Five signed and dated paintings document Inness's trip to Tarpon Springs in 1892. *Moonlight, Tarpon Springs, Florida* is among these. In this painting there is a sense of harmony between man and nature "where neither man's work nor God's is dominant" (Mackle 1977: 182). A woman walks along a moonlit road bearing a basket, and "there is a sense of measured cadence, as though this painted world operates through some slowed down pace, through some frame of reference that is alien to ours" (Davis 1978: 119).

In 1893, on what was possibly Inness's third trip to Tarpon Springs, he painted six canvases that he signed and dated, as well as two more that are attributed to this time. *Early Moonrise in Florida* (1893) was one of these and is typical of the many mysteries that surround Inness's work. Somehow it was titled *July Moonrise in Florida,* though it is most unlikely that Inness was in Florida in July 1893. Possibly, *Early Moonrise in Florida* had been painted from memory in July, "for the greatest of his masterpieces were painted within the four walls of his studio" (Schlageter 1980: 13). Inness felt so strongly that an artist must be able to master the ability to render from memory that he advised his son to "Draw, draw, draw, learn your art thoroughly, have it at the tips of your fingers, be able to do it with your eyes shut" (Schlageter 1980: 13). *Early Moonrise in Florida,* which depicts a monk-like figure, arms outstretched as if holding an offering to the rising moon, conveys the mystical aura that so often prevailed in Inness's later works. *Orange Road, Tarpon Springs, Florida* (1893) and *The Road at Tarpon Springs, Florida,* or *Moonlight* (1893) were also done on this trip and they, too, reveal the spirituality of the mature Inness. These scenes,

19

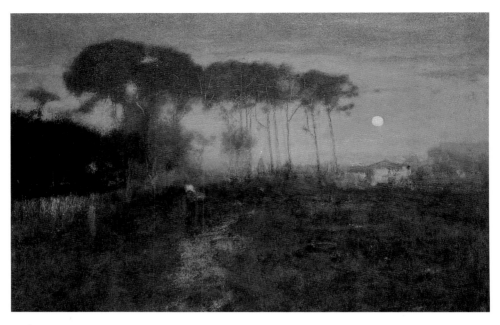

George Inness
Early Moonrise in Florida, 1893
Oil on canvas, 24³/₈″ x 36¹/₄″
Memorial Art Gallery of the University of Rochester
George Eastman Collection of the University of Rochester, New York

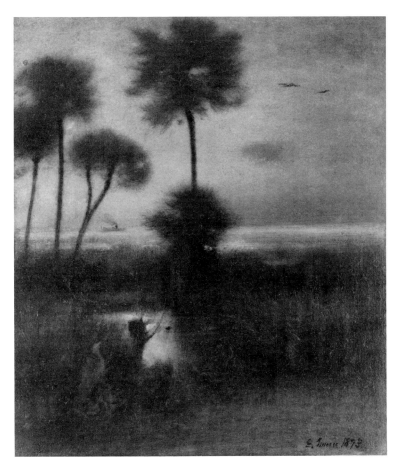

George Inness
Home of the Heron, 1893
Oil on canvas, 26" x 22"
Florida Gulf Coast Art Center, Belleair, Florida

like all of the artist's successful paintings, capture a moment in nature—its light, color, and air. Inness advised his son George, Jr., that the painted landscape should be full of light and air and be animated by transparent colors: ''There you see, George, the value of the grey color underneath glazing. The transparency of it comes out in the tone. The shadows are full of color. Not pigment; all light and air. Wipe out a little more of it. Never was anything as nice as transparent color'' (Davis 1978: 117). *Home of the Heron* was also painted during this third trip. This painting intercepts nature at its most subtle moment, producing, in Davis's (1978: 119) words, ''a reflection, a spectral afterimage of another more sharply etched landscape—and that is, because of the mist and the ensuing softening of forms—but the strange remoteness is produced by something else, which is a bit hard to get at when we try to put our finger on it.'' In *Eventide, Tarpon Springs, Florida*

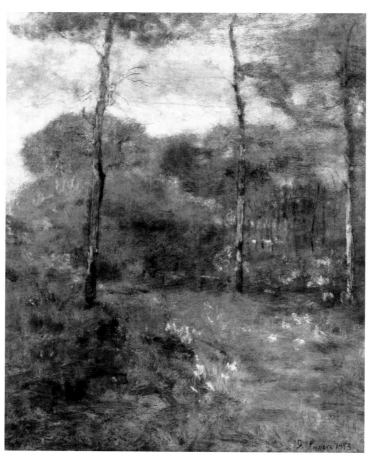

George Inness
Orange Road, Tarpon Springs, Florida, 1893
Oil on canvas, 30″ x 25″
Indianapolis Museum of Art
Gift of Mrs. James L. Rose in memory of her mother, Mrs. William A. Smith

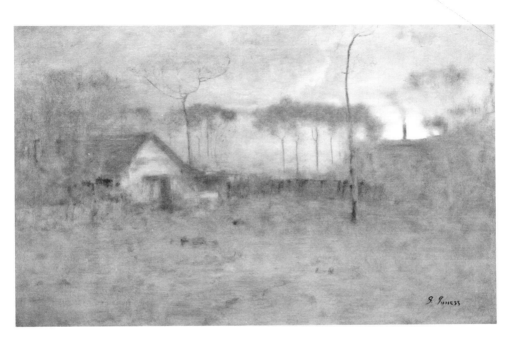

George Inness
Eventide, Tarpon Springs, Florida, 1893
Oil on canvas, 29$^{1}/_{2}$" x 44$^{1}/_{2}$"
The Art Complex Museum, Duxbury, Massachusetts

(1893), almost the entire image has been obliterated, enveloped in a dense fog that seems devoid of fixed elements. This is similar to Swedenborg's description of the spiritual world, and though Inness does not specifically cite Swedenborg, his published statements reveal his concern for the invisible. He wrote:

> The paramount difficulty with the artist is to bring his intellect to submit to the fact that there is such a thing as undefinable—that which hides itself that we may feel after it. The intellect seeks to define everything; its cravings are for what it can see, lay hold of, measure, weigh, examine. But gold is always hidden, and beauty depends on the unseen—the visible upon the invisible (Owens and Peters 1982: 65–66).

In 1894, Inness created his last paintings of the Tarpon Springs area. One of these, *Rosy Morning* (1894), is of incredible lyrical and mystical beauty. An early morning sunrise illuminates the setting, highlighting the foliage with a radiant glow. The small figure seems real and tangible; we can almost stand beside her and become part of this ethereal world. God and nature are indeed one in *Rosy Morning.*

Throughout his later years, George Inness attempted to reconcile his sense of vision with his emotional experiences, an intimate struggle that appears to have led him to a balanced harmony between nature and religion.

B.S.

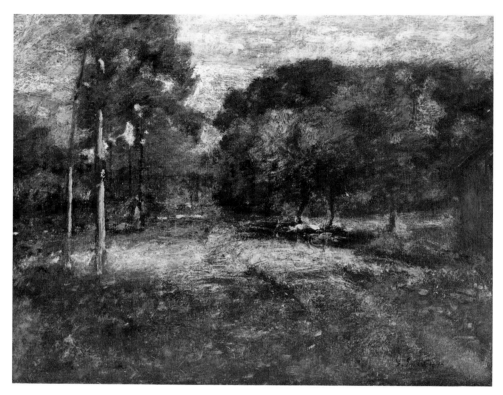

George Inness
The Road, Tarpon Springs, Florida, or *Moonlight,* 1893
Oil on canvas, 25¹/₂" x 30³/₈"
Lowe Art Museum, University of Miami, Miami, Florida
Gift of Mr. and Mrs. Myron Hokin, 1955

Bibliography
Craven, Roy C., Jr.
 1965 *Artists of the Florida Tropics.* Gainesville, Florida: University Gallery.
Davis, Abraham A.
 1978 *The Eccentrics and Other American Visionary Painters.* New York: E. P. Dutton.
Mackle, Elliot James, Jr.
 1977 "The Eden of the South: Florida's Image in American Travel Literature and Painting."
 Doctoral dissertation. Atlanta, Georgia: Emory University.
Owens, Gwendolyn, and Peters, John Campbell
 1982 *Golden Day/Silver Night: Perceptions of Nature in American Art, 1850–1910.* Ithaca, New York:
 Herbert F. Johnson Museum of Art, Cornell University.
Schlageter, Robert W.
 1980 *George Inness in Florida: 1890–1894.* Jacksonville, Florida: Cummer Gallery of Art.
Sheldon, G. W.
 1978 *American Painters.* New York: Benjamin Bloom, Inc.

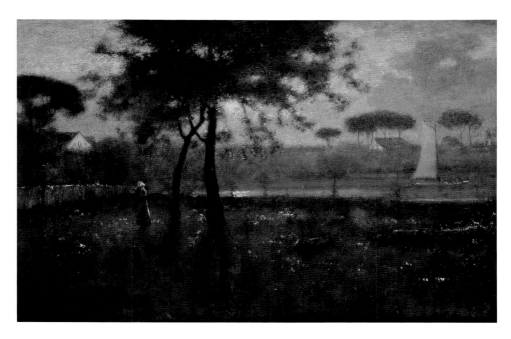

George Inness
Rosy Morning, 1894
Oil on canvas, 30" x 45"
Hunter Museum of Art, Chattanooga, Tennessee
Given in memory of Laura Voigt and Joseph Howard Davenport by the Joseph H.
 Davenport, Jr., family

Louis Remy Mignot (1831–1871)

Louis Remy Mignot was born in Charleston, South Carolina, in 1831. He studied drawing as a boy and traveled to Holland when he was twenty years old, continuing his artistic studies there. By 1855, Mignot was living again in the United States, this time in New York. He traveled to Ecuador in 1857 with the landscape painter Frederick Edwin Church, and as a result of this journey he began to produce the works that caused the writer Henry T. Tuckerman to term him ''the efficient delineator of tropical atmosphere and vegetation'' (Tuckerman 1966: 563). In 1858, Mignot was elected to the National Academy of Design in New York; the next year he worked with Thomas P. Rossiter on the painting *Washington and Lafayette at Mount Vernon*. The painter was loyal to his native state, and when South Carolina seceded from the Union in 1860, Mignot felt he was unable to live in America any longer. He moved to London, where he lived for the rest of his life. Mignot first exhibited in London at the Royal Academy in 1863 and had his last exhibit there in 1871. His work was also shown at the Paris Exposition of 1867 and at the National Academy in the United States the next winter. Mignot died in 1871 and was given a retrospective show in London some time thereafter.

Mignot's artistic sensibilities centered around the use of color to evoke the atmosphere appropriate to the setting. Tuckerman (1966: 563) said that Mignot ''has a remarkable facility of catching the expression, often the vague, but, therefore, more interesting expression of a scene.'' Tuckerman's use of the word ''expression'' to describe Mignot's landscapes was particularly apt. The artist was far ahead of his time, and his innovations pointed toward the emphasis on expression and gesture that would be seen in modern painting. The use of visible brushstrokes as an active participant in the formal qualities of painting was uncommon in his time, yet Mignot's broad strokes show little regard for the careful modeling and tight painting of the major works of his friend Frederick Edwin Church and those of the German-trained Albert Bierstadt. Mignot chose to depict what the French Impressionists wanted to reproduce: the overall atmosphere and underlying qualities of a particular landscape. Mignot had no intention of recording every detail, for he was interested in a holistic effect; Tuckerman (1966: 563) used the word ''vague'' to mean the nuances that one absorbs somewhat unconsciously as one surveys the world. A British critic said of Mignot's work: ''We recognize at once its naturalness, not merely in passages, but in the harmonious treatment of the whole'' (Tuckerman 1966: 564). In *Sunset Landscape* (1863?), Mignot applied searing reds, oranges, and yellows with his characteristic energetic brushstrokes. The sky is alive with glowing color and surging vitality, while below, half hidden in the dusk, a long-legged bird picks his way quietly through the tall grass, silhouetted by the pond behind him. A large palm, painted broadly but accurately, anchors the left side of the painting, while at the far right, a group of palms is painted with just a few short strokes, all that is necessary to suggest their forms. Mignot concentrated on capturing the color variations that nature creates in the

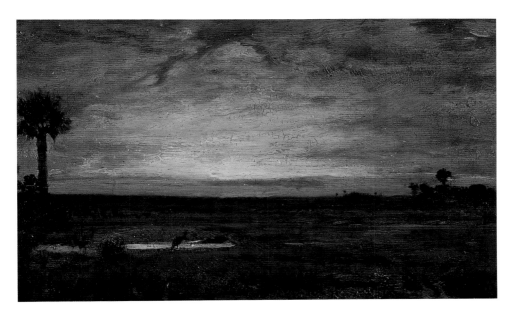

Louis Remy Mignot
Sunset Landscape, 1863(?)
Oil on panel, 5³/₄" x 9¹/₄"
Anonymous Florida Collection

sky and earth at sunset. He painted these colors somewhat roughly, as if they were splashed on quickly, to give the effect of immediacy, with little interest in the studied, careful modulation from color to color that Bierstadt would have painted. That Mignot was able to encapsulate the grandeur and intensity of a Florida sunset in this small work attests to his ability to create an atmosphere using the barest of necessities. With color as his primary tool, Mignot produced a painting that is a "most complete little work" (Tuckerman 1966: 564).

C.J.

Bibliography
Tuckerman, Henry T.
 1966 *Book of the Artists.* New York: James Carr Publisher.
Waters, Clara Erskine Clement, and Hutton, Laurence
 1969 *Artists of the Nineteenth Century and Their Works.* 7th Ed. New York: Arno Press.

William Morris Hunt (1824–1879)

William Morris Hunt was a gifted artist and teacher and a brilliant orator who had a profound impact on the Boston art scene during his years teaching and painting there. His passionate lectures calling for new directions in art were heard by many who worked to bring about the changes that he espoused. In fact, Hunt's influence was one of the primary reasons that Boston became the first American city to recognize the importance of the Barbizon School painters. Hunt's brother, Richard Morris Hunt, the architect of the Vanderbilt houses, ''Biltmore'' and ''The Breakers,'' was also an important artistic presence.

William Morris Hunt was born in Brattleboro, Vermont, in 1824. He attended Harvard University from 1840 to 1843, then traveled with his family to Europe, where he studied in Rome with the American sculptor Henry Kirke Brown from 1843 to 1844. He made a trip to Greece and Turkey in 1845, briefly returned to the United States, then went to Germany to study art at the Dusseldorf Academy from 1845 to 1846. Unhappy with the mechanical style taught there, he left the German school about nine months later. He entered the Paris atelier of academic painter Thomas Couture in 1846 and learned to paint with an accurate but economic and spontaneous technique. (From 1850 to 1855, Edouard Manet also studied with Couture.) Hunt exhibited the results of his years with Couture at the Paris Salon in 1852, but by 1852–53 he had become more interested in the work of Jean-Francois Millet. Hunt went to live in Barbizon, France, to work with Millet and the other Barbizon painters, whose style and artistic philosophy better suited his own. Hunt strongly agreed with Millet's conviction that emotion should be at the heart of art and, with new interest in the content of his paintings, immediately changed his subjects to reflect nature and everyday life rather than ornate studio contrivances. Hunt exhibited works painted in this new style at the Universal Exposition of 1855 in Paris. That year the artist returned to America, where he married Louisa Dumaresq Perkins, settled in Newport, Rhode Island, and opened a studio for himself and his students, who included Henry and William James and John La Farge. Hunt remained in Newport until the beginning of the Civil War at which time he moved to Boston. Although Hunt's family finances allowed him to play the dual roles of art patron and artist, his decision to become a portrait painter probably resulted from the prevailing American disinterest in, and/or ignorance of, new artistic concepts emphasizing nature and simpler subjects.

Hunt exhibited infrequently for the rest of his life because his use of thick layers of paint in the Barbizon School style aroused the ire of critics. In 1868 he began teaching large classes of women, and one of his students, Helen Knowlton, collected and published his insightful lectures and art critiques as *W. M. Hunt's Talks on Art* (1875). By 1877 those artists whose work Hunt had collected and championed, such as Millet and Narcisse Diaz de la Pena, were becoming accepted, and the attitude toward art and artists, including Hunt, had changed. Hunt took this opportunity to express himself more freely in landscape paintings. After the great Boston fire of 1872, in which Hunt lost most of his art collection and his own work, the artist made his first journey to northeastern Florida to visit financier John Murray Forbes at Magnolia Springs, a resort near Jacksonville. During this vacation, he painted Florida landscapes; the following spring he returned to Florida, after a visit to Cuba. In 1875, Hunt took a trip to Mexico; then, for the next few years, he traveled around New England, painting portraits and landscapes. He built a studio in the Massachusetts countryside in 1876 and painted many of his finest late landscapes in the surrounding areas. In 1878 he received a commission to paint two large lunettes on a vaulted ceiling forty-five feet above the Assembly Chamber of the State House in Albany, New York, but was forced to finish the murals in under two months

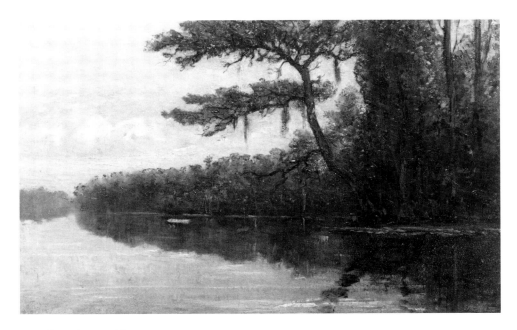

William Morris Hunt
Florida Landscape, 1875
Oil on canvas, 25" x 39"
Dr. and Mrs. David A. Cofrin

when the scaffolding was not prepared in time, an effort that completely exhausted him. The next summer, in 1879, while resting at a friend's cottage on the Isle of Shoals, Hunt drowned. His murals were damaged a few years later when water seeped through the Chamber ceiling, weakening the vaulting and loosening the paint. Another ceiling was later built to conceal Hunt's ruined works.

Hunt's *Florida Landscape* (1875), painted several years before his death, is the result of a lifelong commitment to art and to the development of new and better ways in which to approach art. In 1875, Hunt turned away from the boredom of portraiture and set himself the task of painting landscapes. For this artist, accustomed to the northern scenery, illustrating the subtropical atmosphere of Florida was a challenge. He used the techniques and ideas that he had acquired while in France and New England, two vastly different geographical locations, and discovered that the Barbizon concepts of art ''based on imagination, memory and brilliant technique'' were applicable to Florida's topography as well (Bermingham 1976: 8). Along with George Inness, Hunt was one of the earliest and most significant American landscape painters to be influenced by the Barbizon School. Based on the artistic philosophies of painters like Millet and Diaz, Hunt formed a personal view of art which, at first, was considered highly controversial by the still tradition-bound taste of Boston art patrons. In his lectures on art, Hunt advocated painting indoors from memory but with a freedom of execution. He told his students that they should ''keep the first vivid impression! Add no details that shall weaken it!'' (Knowlton 1875: 3). In the final years of his life, however, Hunt became increasingly interested in capturing the effects of

natural light and color and painted more often outside. The softly radiant hues of peach and pink lighting the open sky in the upper left of *Florida Landscape* capture the ephemeral beauty of a sunrise or sunset. Hunt's finely observed glowing light shows that he was attempting to follow his new goal of painting such momentary natural phenomena, yet the stillness of the scene suggests that the moment is eternal as well. The glassiness of the river, the motionless trees with neither moss nor branches swaying in the breeze, the lack of definition in the details, the bushes and leaves as clouds of green-gray color, all create a timeless image of a peaceful Florida river. Hunt had not completely relinquished his initial idea that painting was at its best when certain values were only suggested, not spelled out. He was following his own advice that one should ''try not to see as much as you see'' (Knowlton 1875: 174), for he believed deeply that ''painting is appreciation of the form, character, and color of the things, not oil or varnishes'' (Knowlton 1875: 16). Hunt's imaginative and dreamy Florida landscape merely suggests the subtle wonders to be found in nature.

C.J.

Bibliography
Bermingham, Peter
 1976 *American Art in the Barbizon Mood: The National Collection of Fine Arts.* Chicago: University of Chicago Press.
Knowlton, Helen
 1875 *W. M. Hunt's Talks on Art.* Boston: H. O. Houghton and Company.
Landgren, Marchal E.
 1976 *The Late Landscapes of William Morris Hunt.* College Park: University of Maryland.
Vose, Robert C.; Vose, Abbot W.; and Vose, Robert C. III
 1986 *The Return of William Morris Hunt.* Boston: Vose Galleries of Boston.

Herman Herzog (1832–1932)

Between 1885 and 1910, Gainesville was the intermittent host to a German-born landscape painter. Traveling by rail from Philadelphia, Herman Herzog journeyed south to visit his son, "a successful bachelor chemist" at the University of Florida (Lewis 1974: 5). The record of his Florida sojourns is a series of personal, deeply evocative landscapes that expresses an American aesthetic yet maintains a European sensibility.

Herman Herzog was born in Bremen on November 15, 1832. Intent on becoming an artist, the young Herzog overcame the objections of his family and friends and enrolled at the Düsseldorf Academy in 1848 (Lewis 1974: 1). Under the guidance of J. W. Schirmer, Hans Frederick Gude, and Andreas Achenbach, the spell of the landscape seduced the young painter (Lewis 1974: 2).

On numerous trips abroad to Switzerland, Norway, Italy, and the Pyrenees, Herzog drew and painted mountain landscapes and began to formulate a personal style. The reputation of the young artist increased during this period, and the list of Herzog's patrons grew to include the crowned heads of Europe. Queen Victoria, the Grand Duke of Oldenburg, Emperor Alexander of Russia, and the Countess of Flanders were among those who purchased his pictures (Lewis 1974: 2).

In the late 1860s, the artist, his wife Anne, and his young son left Germany for America. Herzog's decision to leave was politically, as well as artistically, motivated. Alarmed by Bremen's growing alliance with Prussia, Herzog said, "I'd be damned if I would live and bring up my children under Prussian rule" (Lewis 1974: 3). Moreover, the possibilities inherent in the American landscape must have been an additional inducement. Settling in Philadelphia, where he had friends and his work was known, Herzog exhibited regularly at the Pennsylvania Academy of Fine Arts and on occasion at the National Academy of Design (Lewis 1974: 4–5).

A prolific painter, Herzog produced some one-thousand works before his death in 1932. Considered quaint by early twentieth-century standards, Herman Herzog's work has only recently been "rediscovered." His failure to keep abreast of contemporary trends caused him little worry. When questioned about modern artists on the eve of his one-hundredth (and last) birthday he said, "They have the knack of catching the hurry-up spirit of the day. So, after all, probably they are the true portrayers of the era. I can't tell. We did it differently" (Levin 1973: 95).

In his "Essay on American Scenery" (1836), Thomas Cole praised the poetry and majesty of the American landscape. His prose extolls the awesome sublimity of jagged precipices and the discomforting quiet of deep, dark forests. Anticipating the contribution of the succeeding generations of American landscape painters, Cole writes:

> I will speak of another component of scenery, without which every landscape is defective—it is water. Like the eye in the human countenance, it is a most expressive feature: in the unrippled lake, which mirrors all surrounding objects, we have the expression of tranquility and peace—in the rapid stream, the headlong cataract, that of turbulence and impetuosity (1836: 8).

Of his Florida paintings, Herman Herzog is at his expressive best in those which capture the shifting relationship between water and light. In *Landscape with Heron* (n.d.), Cole's personification is subtly at play. Like the human eye, the stream, in its gentle meander, reflects its surroundings. On the mirror-like surface, a mosaic of pink, gold, and blue heralds the rising sun. The solitary witness to this scene is a heron, standing quietly in midstream. The immediacy of this timeless tableau is conveyed by Herzog's emphasis on the foreground. The heron in his stream is part of a shallow stage which is contained by

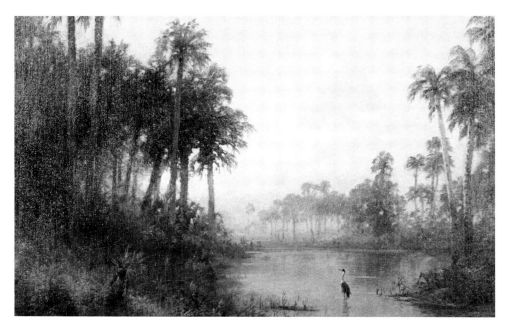

Herman Herzog
Landscape with Heron, n.d.
Oil on canvas, 26″ x 34″
Dr. and Mrs. David A. Cofrin

the vertical palms rising above banks dense with vegetation. Beyond, a narrow spit of shore crowned with trees leads the eye to the dreamy, atmospheric perspective on the horizon.

Similar in subject, yet altogether different in mood is *Forest with Heron* (n.d.). An inscription on the stretcher reads: "Lower Waccassa River." From a spring-fed source near Alachua County, the river eventually discharges into the Gulf of Mexico between the modern communities of Cedar Key and Yankeetown, Florida. Even today the area is a swampy wilderness. Once again, Herzog presents a moment frozen forever. In a small cove of the river, wading past the floating vegetation, a heron stalks. Ringing this stage are palms, towering above the surrounding plants. That this is a winter scene is indicated by the stark, barren forms and gray tonal qualities that Herzog gave the forest. The palm fronds, activated by a breeze, reflect the golden light of an afternoon sun. The extreme close-up of the setting does not permit this brilliant play of light to be reflected in the murky water below.

The analogy of Herzog's compositional effects to that of theatre is not arbitrary and can be traced to the Düsseldorf Academy in Germany, where he received his training. Wend von Kalnein (1972: 17) has noted that artists of the Academy enthusiastically participated in plays and theatrical events. Furthermore, von Kalnein (1972: 17) suggests "the shallow foreground of the paintings where the action takes place is directly related to the uncluttered front of the stage where the theatrical 'tableau vivant' was placed."

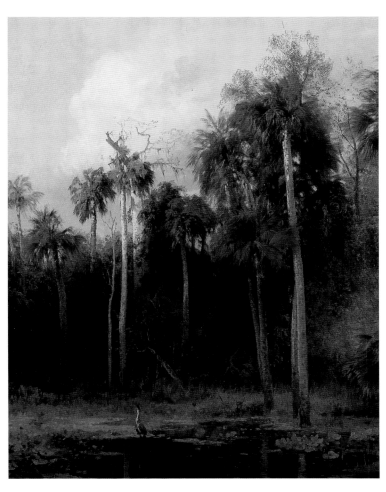

Herman Herzog
Forest with Heron, n.d.
Oil on canvas, 39" x 32"
Dr. and Mrs. David A. Cofrin

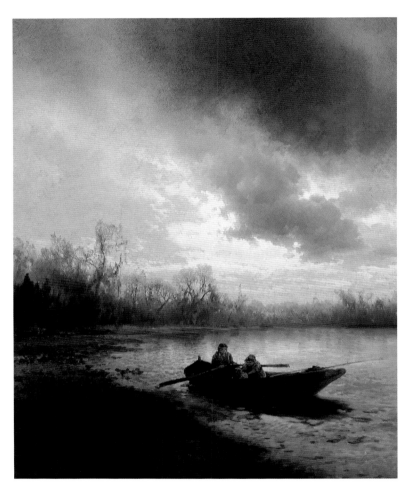

Herman Herzog
On Alachua Lake, n.d.
Oil on canvas, 39″ x 32″
Dr. and Mrs. David A. Cofrin

On Alachua Lake (n.d.) continues the theme of light and water. This vast sinkhole, known today as Payne's Prairie, no longer contains a lake. During the nineteenth century, however, water had risen high enough to make transportation possible. A steamboat was even used to ferry goods and passengers between Micanopy and Gainesville. Herzog ignored these mundane mercantile activities. His vision of Alachua Lake is poetic and eternal. The water's surface is a stage upon which a slow, gentle *pas de deux* between rowboat and reflected clouds is danced. In this winter scene, gray leafless trees draped with Spanish moss present a ghostly spectre on the shore. *On Alachua Lake* succeeds, in great part, due to Herzog's observational and painterly skills in rendering clouds. In this

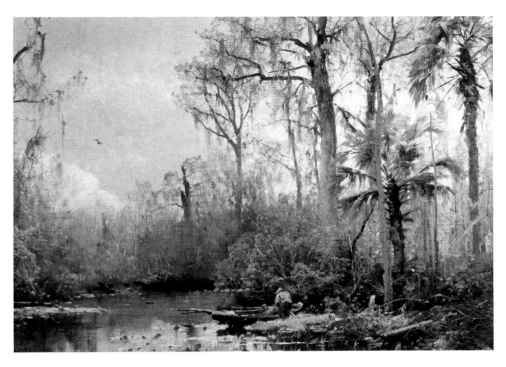

Herman Herzog
Figures in a River Landscape, n.d.
Oil on canvas, 15³/4" x 19³/4"
Cummer Gallery of Art, Jacksonville, Florida
Gift of Mr. and Mrs. C. Herman Terry

picture, he combined narrow bands of nimbus along the horizon with fluffy white cumulus and dark thunderheads to create a rich meteorological patchwork. Novak (1980: 97) has termed this type of treatment "atmospheric virtuosity," the wholesale use of which by American landscape artists is distinct from that of their European counterparts.

Completing the Herzog grouping where water is prominently featured are *Figure in a River Landscape* (n.d.) and *Florida Marsh* (n.d.). Ancient cypress command the focal point of *Florida Marsh.* In graduated fashion, like so many stair-steps, they create a diagonal dividing the composition in half. Also, Herzog has widened his "stage" to allow the foreground to contain more of the reflection of the surrounding trees and sky. Herzog created the illusion of vast, open space in *Florida Marsh* by cleverly painting a stream that spatially is mirror-image to the sky above. Thin pink wisps of clouds divide this space into a series of horizontal receding planes. Likewise, the tapestry of the water's surface is intersected by dark lines, echoing the configuration overhead. This manner of organizing space through a series of receding planes parallel to the surface is a Luminist convention (Novak 1979: 105). Its use here clearly points to Herzog as the inheritor of this tradition. Detail is executed with a photographic quality in *Figure in River Landscape* (n.d.). Herzog was intrigued with photography, and some of his later paintings were completed in the

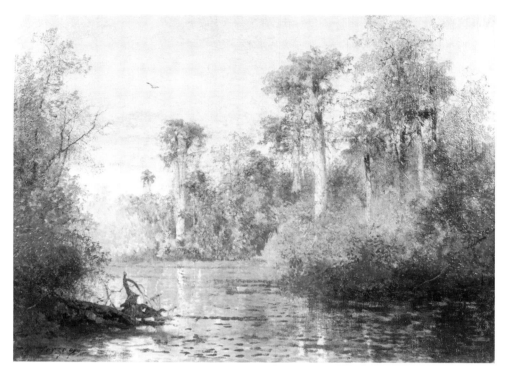

Herman Herzog
Florida Marsh, n.d.
Oil on canvas, 15⁵/₈" x 20¹/₂"
Robert P. Coggins Collection of Southern American Art

studio based on photographs and sketches made while in the field (Lewis 1974: 7). Returning to a close-up view, Herzog presents the human element in harmony with nature. Perhaps pausing to untangle a fishing line, the figure is dwarfed but not diminished by his surroundings. The winter sky darkens with an approaching storm, again displaying the meteorological expression at which Herzog was so adept.

The leimotif of the ''human incident'' to suggest harmony and serenity pervades *Scene on Snake Key Gulf Coast* (n.d.). Although grouped thematically with the previous works in the exhibition which center around water, here the sea is reduced to a narrow, hazy blue band, and the artist has emphasized the contrast of brilliant sunlight with deep shadow. From the shadow of a stand of palms, a red-coated hunter and his dog emerge. The rhythm of *Scene on Snake Key Gulf Coast* is hypnotic. Gentle curves are used throughout, from the undulating line formed by the crest of the vegetation to the giant cumulus crescent overhead. Unusual is the sweep of the picture. For although the hunter and his element are appropriately in the foreground, Herzog opens up the background in a gesture approaching the panoramic.

Landscape with Fox and Bird (n.d.) and *Landscape with Three Deer* (n.d.) depict a unique vision of the Florida wilderness. For in these two paintings Herzog presents the forest in

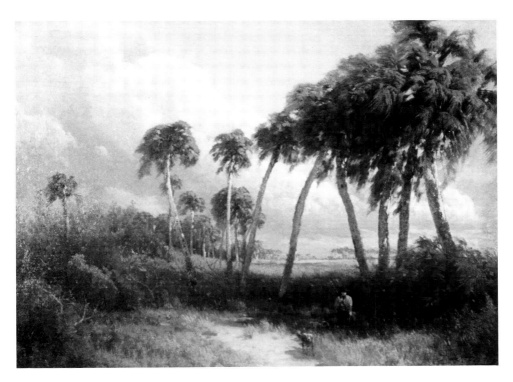

Herman Herzog
Scene on Snake Key Gulf Coast, n.d.
Oil on canvas, 16″ x 21″
Dr. and Mrs. David A. Cofrin

its complex cycle of growth, survival, and decay. Thomas Cole's observations on the American forest do much to explain the lure of this verdant wonderland, especially to painters like Herzog, schooled in the European tradition.

> In the Forest scenery of the United States we have that which occupies the greatest space, and is not the least remarkable; being primitive, it differs widely from the European. In the American forest we find trees in every stage of vegetable life and decay—the slender sapling rises in the shadow of the lofty tree, and the giant in his prime stands by the hoary patriarch of the wood—on the ground lie prostrate decaying ranks that once waved their verdant heads in the sun and wind. These are circumstances productive of great variety and picturesqueness—green umbrageous masses—lofty and scathed trunks—contorted branches thrust athwart the sky—the mouldering dead below, shrouded in moss of every hue and texture, form richer combinations than can be found in the trimmed and planted grove....Trees are like men, differing widely in character; in sheltered spots, or under the influence of culture, they show few contrasting points; peculiarities are pruned and trained away, until there is a general resemblance. But in

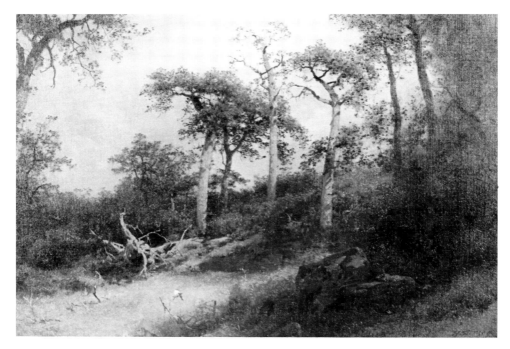

Herman Herzog
Landscape with Fox and Bird, n.d.
Oil on canvas, 20″ x 28″
Dr. and Mrs. David A. Cofrin

exposed situations, wide and uncultivated, battling with the elements and with one another for the possession of a morsel of soil, or a favoring rock to which they may cling—they exhibit striking peculiarities, and sometimes grand originality (1836: 11–12).

The wilderness of *Landscape with Fox and Bird* and *Landscape with Three Deer* is an idealized Arcadia. Details are deemphasized with the resulting soft focus imparting a dreamy, romantic mood. Although the setting is Florida, it is interpreted with a European sensibility. The influence of Johann Wilhelm Schirmer upon his pupil Herman Herzog is felt most strongly in these two works. The trees in Schirmer's landscapes are gnarled yet noble individuals placed within a setting that looks surprisingly tame. Similarly, Herzog's trees are ancient and graceful.

The Florida paintings of Herman Herzog represent a synthesis of American and European trends in nineteenth-century art. From the Düsseldorf Academy and exposure to romantic painting of the time, Herzog gained an appreciation for nature. To this was added the influence of the Hudson River and Luminist painters in America. Not to be overlooked is Florida's contribution, for it was here that Herzog discovered an unspoiled landscape ideally suited to his special vision.

E.M.W.

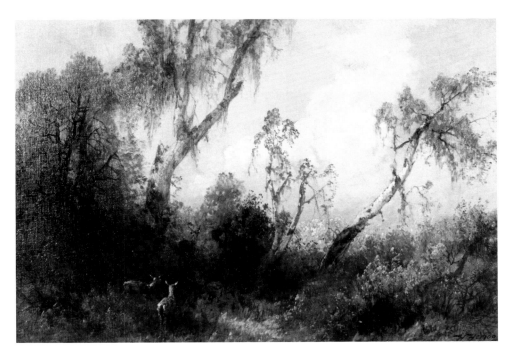

Herman Herzog
Landscape with Three Deer, n.d.
Oil on canvas, 23″ x 33″
Dr. and Mrs. David A. Cofrin

Bibliography
Cole, Thomas
 1836 "Essay on American Scenery." *American Monthly Magazine* (January).

Levin, Kim
 1973 "Herman Herzog." *Art News,* vol. 72 (October).

Lewis, Donald Sykes, Jr.
 1974 "Herman Herzog." Unpublished Master's thesis. McIntire Department of Art, University of
 Virginia.

Novak, Barbara
 1979 *American Painting of the Nineteenth Century.* 2nd Ed. New York: Harper and Row.
 1980 *Nature and Culture: American Landscape and Painting, 1825–1875.* New York: Oxford University
 Press.

Von Kalnein, Wend
 1972 "The Düsseldorf Academy." *The Düsseldorf Academy and the Americans,* by Gudmund Vigtel,
 Wend von Kalnein, and Donelson F. Hoopes. Atlanta, Georgia: The High Museum of Art.

Winslow Homer (1836–1910)

Winslow Homer, renowned as one of America's greatest artists, was born in Boston on February 24, 1836. At the age of eighteen he was apprenticed to the lithography workshop of John Bufford and Sons, where he worked on sheet music covers. By 1857, Homer had left Bufford's to accept free-lance assignments with *Ballou's Pictorial* and *Harper's Weekly*. In 1859 the artist moved to New York and for several years attended evening classes at the National Academy of Design. His first critical acclaim was for a series of Civil War images he created on assignment for *Harper's*. By 1863, Homer was exhibiting regularly at the National Academy, and by 1866 his painting *Prisoners from the Front* was so well received that he was elected academician of the National Academy. After a ten-month visit to France, the artist returned to New York and continued to free-lance for a variety of journals and publishers while making frequent summer visits to the New England countryside.

In 1873, during a June and July stay in Gloucester, Massachusetts, Homer created his first watercolor series. A few years later he ended his career as an illustrator for *Harper's Weekly* and was elected a member of the American Watercolor Society. Homer's watercolors were most often the product of his prodigious travels, his subjects suggested by the various locales he visited. Throughout the 1870s his themes were of the simple life, leisure, and childhood. By the 1880s his major theme had become man's place within nature, a subject he explored during a twenty-month stay at Cullercoats, Northumberland, England. Upon his return to New York, Homer found himself seeking an environment of isolation in which to work. He found, in Prout's Neck, Maine, that place, and his future home.

Homer first visited the tropics in 1884 to illustrate an article on Nassau. By 1886 he ventured into Florida, ostensibly to fish, although he created works during three of his seven visits to the state between 1886 and 1909. In the 1890s, Homer frequently traveled to the Adirondacks and Quebec in the summer and fall months. Throughout this period his oil paintings were increasingly bought and collected by major museums, and in 1908 the Carnegie Institute organized a major exhibition of Homer's works, borrowing half of the pieces from public collections. The last five years of Homer's life were characterized by ill health and the delusions that his works did not sell quickly enough and were unappreciated. After suffering a stroke in 1908, Homer never fully recovered his strength, and in September of 1910 he died at his home in Prout's Neck.

Homer created watercolors on three separate visits to Florida in 1886, 1890, and 1893–94. Each series offers a different vision of the state. In 1890, the artist visited the St. Johns River, staying at the fishing resort town of Enterprise. Almost all of his watercolors from this trip depict the angler in quiet expanses of water that are full of delicate nuances and suffused with atmospheric reflections. In *The White Rowboat: St. Johns River* (1890) three fishermen loll lazily in their skiff, observed only by an osprey perched in a nearby tree. They become almost incidental in this scene of land, sky, and slowly flowing river. In 1903, Homer spent the month of December in Key West. Guided by his strong sense of composition, Homer used energetic brushwork to quickly and suggestively depict a series of sailing ships at anchor, effectively creating an atmosphere filled with light and color. One of these, *Hauling in Anchor* (c. 1903–1904), features a cast of characters expressively delineated in black and brown wash. Two pigs, chickens, and one figure, hand on hip, are at the stern. Midship are two horses, while at the bow three figures strain to raise the anchor. Homer's frequent use of rubbed areas to highlight are evident above the boom and along the halyards of the boat. Touches of red impasto are used sparingly and draw the eye to the scene. The teal blue water is highlighted with green, and the sky

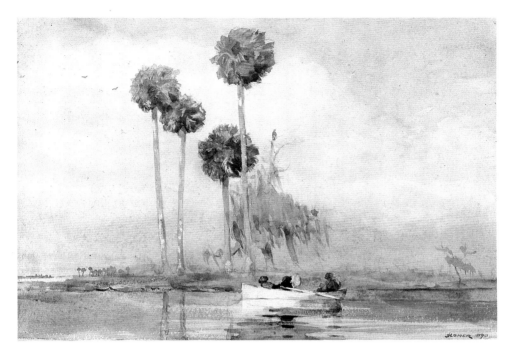

Winslow Homer
The White Rowboat: St. Johns River, 1890
Watercolor on paper, 13¹/₂″ x 19¹/₂″
Cummer Gallery of Art, Jacksonville, Florida
Bequest of Ninah M. H. Cummer, 1958

characteristically contains soft washes of pink. In January of 1904, Homer traveled north to Homosassa, where he indulged his love of fishing and created his last series of watercolors. In works such as *Homosassa River* (1904) he imbues the river scene with rich washes of watercolor that illuminate the depth and reflective qualities of the water and underscore the relatively insignificant role of man. *In the Jungle* (1904) conveys, through the romantic depiction of Florida's wildlife, Homer's power to portray the extraordinary. Here, the artist returns the untamed habitat to its rightful owner, the ferocious cat. The panther claws at the tree trunk, its head twisted and mouth open in mid-roar. Through Homer's skillful composition, we are transported right to the edge of this magical vision.

R.K.B.

Bibliography
Cooper, Helen
 1986 *Winslow Homer Watercolors.* New Haven: Yale University Press.
Schlageter, Robert
 1977 *Winslow Homer's Florida.* Jacksonville, Florida: The Cummer Gallery of Art.

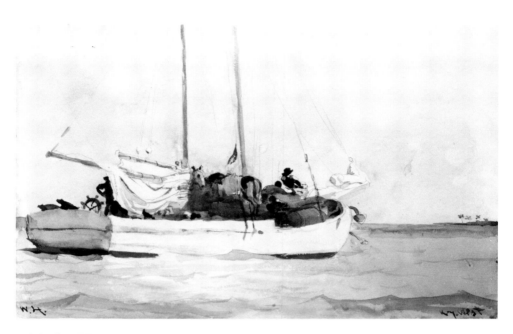

Winslow Homer
Hauling in Anchor, c. 1903–1904
Watercolor on paper, $13^{15}/_{16}$ " x $21^{13}/_{16}$ "
Cincinnati Art Museum
Fanny Bryce Lehmer Endowment

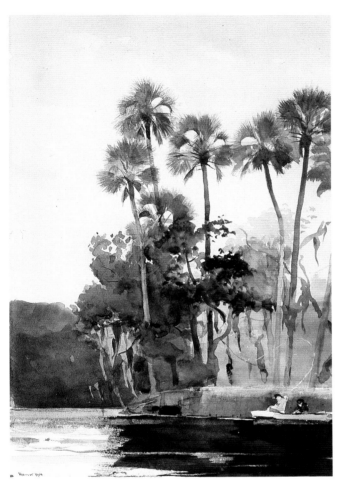

Winslow Homer
Homosassa River, 1904
Watercolor over pencil, 19^{11}/$_{16}$ʺ x 13^{7}/$_{8}$ʺ
The Brooklyn Museum
Museum Collection Fund and Special Subscription

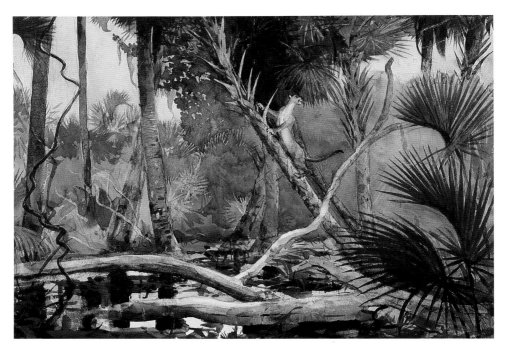

Winslow Homer
In the Jungle, 1904
Watercolor over pencil, 13⁷/₈″ x 19¹¹/₁₆″
The Brooklyn Museum
Museum Collection Fund and Special Subscription

William Aiken Walker (1838–1921)

William Aiken Walker could be considered the quintessential Southern painter. He was born in Charleston, South Carolina, in 1838, lived and traveled in the South through-out his life, and, of course, painted the South. He began painting when he was twelve years old and from the first, he was as interested in recording life around him as in creating a beautiful image. Growing up in the cultural city of Charleston, where art, literature, and music were distinctly influenced by English tastes, Walker had the oppor-tunity to develop his artistic sensibilities: painting, singing, and writing poetry. He re-mained intrigued, however, by the rural areas just outside of the city, and, throughout his painting career, Walker's subjects centered around farm life and wildlife.

John Frederick Herring, an English painter of horses and barnyard scenes, was an early influence on Walker, but the Civil War's devastating effects on the South were to have, perhaps, the greatest impact upon him. Walker joined one of Wade Hampton's voluntary infantry companies in 1860, enlisted officially in 1861, and was wounded that year. He enjoyed the glory of a young soldier, however, and remained in the Confederate Army until 1864. Although forced to leave financially ruined Charleston in 1865 to find buyers for his work, Walker returned often. The artist based himself in Baltimore, but spent a great deal of time traveling in other areas, including Savannah, New Orleans, and Memphis. He also traveled to St. Augustine and Ponce Park, Florida, where he visited numerous friends and acquaintances and painted scenes of rural life. Walker was so enamored of the Southern lifestyle and scenery that he only left twice—on a trip to Cuba in 1869 for two months and to Europe in 1870. Unlike many of his contemporaries, Walker did not seem interested in acquiring European painting techniques. He arrived in St. Augustine in 1889, the year in which Henry Flagler's artists' studios opened, and began the artist's circuit, wintering in Florida and painting and selling finished works in sum-mer resorts like Arden, North Carolina. He traveled all over Florida during his thirty-one winters there but always returned to the east coast, where the fishing and social life were, for him, unsurpassed. Walker also spent some time in Louisiana and Mississippi, but toward the end of his life he traveled only to Arden, Ponce Park, and Charleston, where he died on January 3, 1921.

William Aiken Walker's knowledge of the Florida landscape was intimate, since he lived here every winter for more than thirty years. For twenty-three of those years, he helped to run a boarding house in exchange for room, board, and an office that he used also as a studio. The Pacetti House in Ponce Park was famous for its seafood meals and excellent fishing facilities, both important selling points for Walker, an avid gourmand and fisherman. At this popular boarding house, Walker met wealthy and powerful busi-nessmen who were also fishermen and who often purchased his Florida works. These contacts included C.C. Gregg, a St. Louis manufacturer and sportsman who wrote a book on fishing in Florida. During a cruise on Gregg's yacht along the east coast in 1899, Walker was able to study and sketch the plants, sea life, and topography of the natural coastline before the great building projects of Flagler and others had been long underway. The artist captured Florida just as the building boom began, painting and sketching much of the development which comprises historic Florida. He documented the start of the construction of Flagler's overseas railroad in 1904 and the bridges being built at enormous cost on the way to Key West. He painted lighthouses, the Everglades, the Keys, newly built hotels and churches that are now landmarks, and older buildings and towns, which today are nearly unrecognizable or no longer exist. Walker traveled to the west coast and painted Pensacola (then with a population of 7,000), which was struggling to compete for the tourist trade in northeast Florida. The artist enjoyed his life in Florida at this exciting time. In addition to his fishing companions, he was acquainted with many people inter-

William Aiken Walker
Indian Key, Florida, 1901
Oil on paper, 8" x 10"
High Museum of Art, Atlanta, Georgia
Gift of Mr. and Mrs. George Missbach

ested in the arts. In letters to friends, Walker enthused about the riches of Florida, telling detailed fish stories and describing the sights: ''It would take a volume to describe the beautiful scenery that I have seen, far more lovely than I dreamed of, and every day is one of joy....I got a 6 lb. Pompano, 24 in. long and 8 in. wide, a beauty....We are living well, and our cook edits the Culinary Menu in the good style'' (Trovaioli and Toledano 1972: 47).

Indian Key, Florida (1901) is an oil version of a sketch made in 1899 as part of a series of more than a hundred sketches Walker made from 1898 to 1902 in a documentation of the Florida coastline. These sketches show the Florida coast ''prior to the ecological changes brought about by modern technology and the shifting population'' (Trovaioli and Toledano 1972: 120). In the oil version, however, Walker added his own embellishments that seem to comment on the changes he was witnessing in Florida. In the original sketch, the ramshackle building and bleached skeleton of the dock—the material remains left by man on this windswept spit of land—are similar to those in the oil version. But Walker increased the drama of the scene by painting in the endless onslaught of the wind and waves to show that they had slowly broken down what man had tried to build. Walker did not want to create a scene of absolute desolation and destruction. The palm trees surround and seem to protect the building, and a small rowboat has been pulled up on

46

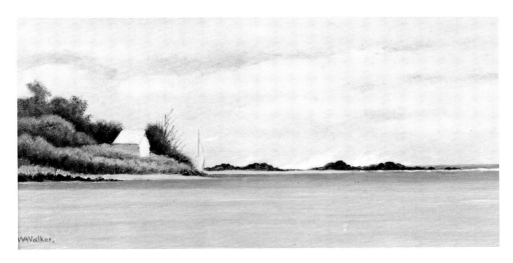

William Aiken Walker
Breakers in Florida, c. 1907
Oil on paper, 5" x 10"
Anonymous Florida Collection

shore in the center, signalling the presence of someone nearby—perhaps a curious tourist or a local fisherman. In either case, the placement of the trees and the boat adds a bit of security and humanity that indicates Walker had not yet become totally disillusioned with the progress of man.

The Florida climate enabled Walker to escape the northern winters, which, as he grew older, he felt with increasing discomfort. Upon his return from a visit to Arden, North Carolina, he wrote, ''How glorious the white breakers and green sea look after the bare cold brown mountains'' (Trovaioli and Toledano 1972: 54). By the time he painted *Breakers in Florida* (c. 1907), Walker was experiencing the effects of the massive development that continually brought in more people, ending forever the friendly and casual lifestyle of the first tourists and creating the ironic modern sense of intense loneliness even when one is surrounded by people. Walker still derived much pleasure from the Florida scenery. When he composed *Breakers,* he chose to paint a simple view of his beloved white breakers and green sea from a distance, lending the scene a remote, almost wild, air. He balanced the empty beach with the comforting presence of the white cottage and sailboat, seemingly the only amenities necessary in such a wonderful environment of sky, sea, and land. The vantage point is from a quiet, calm lagoon, protected from the crashing waves by a thin stretch of pink sand and a natural wall of gray-black boulders, and imparting to the viewer an added sense of security. The melancholic mood, and a sense of powerlessness that perhaps Walker felt as he gazed at the rapidly changing world around him and his former haven in Ponce Park, underlies the tranquility. Walker, through this vision of a still undeveloped Florida coast, seemed to know that he was already painting a view of the past.

C.J.

Bibliography
Trovaioli, August P., and Toledano, Roulhac B.
 1972 *William Aiken Walker—Southern Genre Painter.* Baton Rouge: Louisiana State University Press.

Thomas Moran (1837–1926)

Born into a family of weavers on January 12, 1837, Thomas Moran spent his early childhood in Lancashire, the center of England's cotton industry. In the mid-1840s, Moran's father, "in search of a future free of British class distinctions, and the starvation of being a hand-loom weaver," moved the family to America (Wilkins 1966: 12). They initially settled in Baltimore, then a thriving textile center due to its proximity to the cotton-producing South. To the elder Moran, however, the schools of Baltimore proved a disappointment, and in 1845 the family resettled in Philadelphia.

Thomas Moran's professional artistic career began on his sixteenth birthday when he was indentured by his father to the engraving shop of Messrs. Scattergood and Telfer (Wilkins 1966: 20). The tedium and routine of printing quickly bored the young Moran, and he turned to landscape painting, under the tutelage of the romantic painter James Hamilton. Moran established himself as a painter of historical subjects and landscapes; early works such as *First Ship, San Salvador,* and *Absecon* gained quick acceptance and were exhibited at Philadelphia's Academy of Fine Arts in 1856. During the 1860s, Moran made two visits to Europe, where he managed to spend a great deal of time in England, expressly to admire and study the paintings of J. M. W. Turner. It was Moran's vision of the American landscape, however, that fueled the imagination of his contemporaries and inspired subsequent generations.

Moran's most popular landscapes are connected with the expansion of the American West during the late nineteenth century. A masterpiece of the Western landscape, *Grand Canyon of the Yellowstone* (1872), firmly established Moran's preeminence as principal investigator of the Western scene. The grandeur of his work combined with its realistic, almost photographic, portrayal of the terrain was influential in persuading Congress to set aside Yellowstone as America's first National Park in 1872. Though markedly different from later Florida paintings, the compositional parameters within which Moran worked, namely endless panoramic vistas with an emphasis on soaring verticals, are fully developed in this painting (Gerdts 1964: 203).

A fascination with exotic locales that had long propelled Moran's imagination was rekindled when he read Edward King's *The Great South,* which was originally published in *Scribner's* as a series of travelogues. Moran was commissioned to redraw many of the sketches done by J. Wells Champney, the artist who had accompanied King on his southern tour (Wilkins 1966: 108). When *Scribner's* later asked Moran to visit North Florida to produce illustrations for an upcoming article, he immediately accepted. It was during this trip in 1877 that Moran drew the sketches for his Florida paintings.

Thomas Moran fits squarely into the American tradition of the artist as explorer. The image of the landscape was paramount in his paintings. After his North Florida sojourn, he remained committed to this vision, scornful of developments in contemporary art in America and abroad. Moran's last paintings were completed around 1922 and appear hazy in contrast to the sharp focus he customarily achieved. Thomas Moran died in 1926, at age ninety, in Santa Barbara, California. His daughter Ruth recalled that "he died looking at the cracks of the ceiling, making Venice out of their patterns, just as all his life, he had lingered at marble panels and stained wood, seeing pictures in the lines" (Wilkins 1966: 240).

Moran considered *Bringing Home the Cattle, Coast of Florida* (1879) moody, animated, and one of his best paintings (Wilkins 1966: 117). The work embodies the spirit of a late nineteenth-century Florida, where vast tracts of wilderness succumbed to those brave enough to face the hardships of a pioneer life. Setting the stage, Moran draws upon a favorite source of inspiration, the endless vista. His Western landscapes use soaring verti-

Thomas Moran
Bringing Home the Cattle, Coast of Florida, 1879
Oil on canvas, 32¹/₂″ x 49¹/₂″
Albright-Knox Art Gallery, Buffalo, New York
Sherman S. Jewett Fund, 1881

cals as a framing device to enclose scenes, but here that has been abandoned. Instead, he had opened up the left and center backgrounds to reveal the sweep of marsh and dune. Moran excelled at capturing the romantic mood of a specific time of day. In *Bringing Home the Cattle, Coast of Florida* a late afternoon sky, darkened by the threat of an approaching thunderstorm, overwhelms simple human tasks. Against this panorama the artist has placed a lone cowherd on horseback, directing his charges toward the well-worn path home.

Paintings, like people, acquire unique distinctions throughout their lifetimes. At the Society of American Artists Exhibition in New York in 1879, *Bringing Home the Cattle, Coast of Florida* was rejected in favor of Thomas Eakins's *The Gross Clinic* (Wilkins 1966: 117–118). When the Society lent the exhibition to the Pennsylvania Academy of Fine Arts in Philadelphia, however, Moran received a vindication of sorts. In a triumph of romanticism over realism, the Philadelphians invited Moran to submit the rejected picture over Eakins's *Gross Clinic,* whose graphic realism had made one of the jurors violently ill.

When Moran arrived in St. Augustine on assignment from *Scribner's* in 1877, he found a sleepy coastal village that was far removed from his preconceived notions of Florida. St. Augustine proved a disappointment both in flavor and in opportunities for pictorial subject matter. Two factors rescued what would have been a failed mission: Moran's fascination with Florida's Spanish past and his discovery of an unspoiled wilderness along the mouth of the St. John's River and nearby coastal islands.

Thomas Moran
Fort George Island, Coast of Florida, 1878
Oil on canvas, 25⁵/₈" x 21¹/₂"
Cleveland Museum of Art
Hinman B. Hurlbut Collection

Fort George Island, Coast of Florida (1878), *The Coast of Florida Near the Mouth of the St. Johns River* (1879), and *Fort George Island, Florida* (1878) are companion works. Like all of Moran's Florida pictures, they were painted in his Long Island studio and based on the detailed sketches he made while here. Linking the paintings is the common thread of a stranded sailing craft looking southward along the Atlantic coast.

In *Fort George Island, Coast of Florida,* Moran demonstrates his flair for exotica. From the beached vessel, a strangely dressed couple make their way toward the dunes and the viewer. Elements of the rich tapestry of Florida history that so intrigued Moran have been ingeniously distilled in these two individuals. Balanced against the tri-cornered hat and saber of her companion, the voluminous clothing and burden balanced on the woman's head bespeak a combination of Spanish and African flavors. The scene unfolding in the background was probably less rooted in fantasy in order to depict more accurately the hazards of nineteenth-century navigation. The treacherous north Florida coast has claimed another victim, and a salvage operation has begun to reduce the ship to a skeleton of supporting timbers. Again, Moran displays his affection for narrative captured at a specific time of day by portraying a midafternoon sky that envelops his real and imagined characters.

The 1870s were pivotal years for American landscape artists. Those like Moran, who carried on the Hudson River School tradition of ''paintings panoramic in vision and precise in detail,'' found less critical aclaim for their work (Burke and Voorsanger 1987: 71–72). Increasingly, their work seemed old-fashioned when viewed in light of the Barbi-

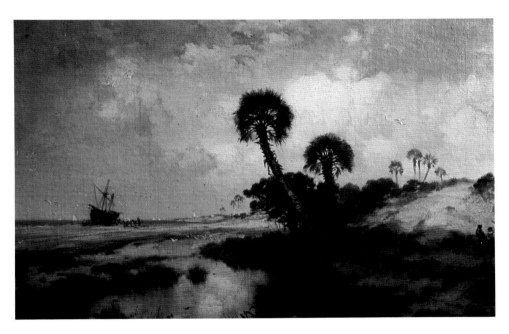

Thomas Moran
The Coast of Florida Near the Mouth of the St. Johns River, 1879
Oil on canvas, 11" x 16"
Nan and Roy Farrington Jones

zon and other contemporary trends in Europe. When *Fort George Island, Coast of Florida* was included in the 1878 exhibition of the Society of American Artists, the show received criticism for displaying Moran's work, which was deemed "a chip off the old Academy Block" (Burke and Voorsanger 1987: 89).

Waning critical acceptance was little deterrent for Moran, who continued to disdain "modern" ideas in favor of the idealized landscape. Like its sister work, *The Coast of Florida Near the Mouth of the St. Johns River* is a fascinating blend of incongruities. Dwarfed against an infinite sky, once again a ship has succumbed to the treachery of the coast and run aground. If we assume the accuracy of Moran's title, the lighthouse in the distance was on Mayport Spit due south across the St. Johns from Ft. George Island. Out to sea, white sails break the horizon; atypical for Florida of this period, these are perhaps more in character with the pleasure craft Moran would have encountered in the view from his Long Island studio. A trio of characters makes their way among the dunes. Attired in costumes out of *Tales of the Arabian Nights,* they introduce the element of fantasy that transports Moran's Florida paintings from the literal to the visionary.

Completing this trilogy of ships and the sea is *Fort George Island, Florida.* In a departure from the previous two paintings, Moran deemphasizes the landscape in this picture. A luxuriant stand of palms and undergrowth has been painted in the right foreground only to provide the vertical framing elements of which Moran was so fond. Commanding the

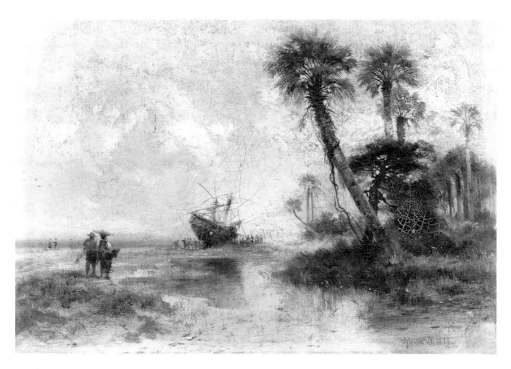

Thomas Moran
Fort George Island, Florida, 1878
Oil on canvas, 9″ x 12¹/₈″
National Museum of American Art, Smithsonian Institution, Washington, D.C.
Gift of Neil M. Judd

viewer's eye in the center of the composition is the stranded ship, listing dramatically to starboard. Like a magnet, this tragedy draws human spectators. The hub of activity centers around the crippled craft, against which, in an effort to keep it upright, a work crew has placed timbers. At intervals in the distance are smaller groups of people. On the beach, two diminutive figures emphasize the vastness of the sea beyond. In the exotic dress that characterizes many of Moran's human subjects, the foreground couple has paused on a dune long enough to survey the scene unfolding beyond. *Fort George Island, Florida* remains an example of the tendency toward pictorial idealization that is apparent in many of Moran's paintings (Gerdts 1964: 203). Abandoning the almost photographic realism of his Western scenes, Moran subordinates individual elements to the broad strokes of color used to render land, sea, and sky.

In *Florida Scene* (n.d.), Moran forsakes the human element to concentrate on the time-less quality of the landscape. Chronologically and in spirit, the romantic, introspective mood of *Florida Scene* places this picture in the second phase of the Luminist Movement. Described as "windows on an empty and serene world," Luminist paintings favored the interactions of land, water, and sky over human associations (Stebbins 1980: 211). As storm clouds gather in the late afternoon sky of *Florida Scene,* the shore is dramatically

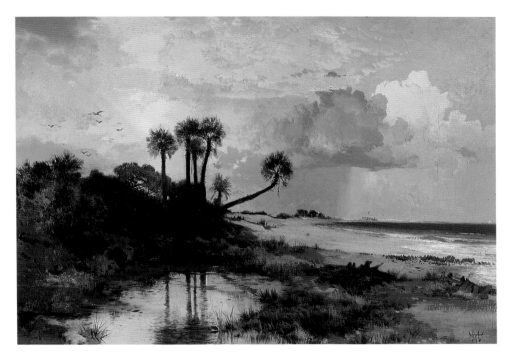

Thomas Moran
Florida Scene, n.d.
Oil on canvas, 10³/₄″ x 15″
Gertrude J. and Robert T. Anderson
Courtesy of the Orlando Museum of Art

highlighted in silhouette and in the reflective tidal pools. A profound stillness permeates the scene broken only by the distant rain and birds flying toward their evening roost. Although considered slightly old-fashioned at the time of its completion, for the modern viewer *Florida Scene* remains the vision of an American wilderness that is, sadly, forever lost.

E.M.W.

Bibliography
Burke, Doreen Bolger, and Voorsanger, Catherine Hoover
 1987 ''The Hudson River School in Eclipse.'' *American Paradise: The World of the Hudson River School,* by John K. Howlat. New York: The Metropolitan Museum of Art, Harry N. Abrams Inc.
Gerdts, William H.
 1964 ''The Painting of Thomas Moran: Sources and Style.'' *Antiques,* vol. 85 (February): 202–205.
Stebbins, Theodore E.
 1980 ''Luminism in Context: A New View.'' *American Light: The Luminist Movement, 1850–1875,* edited by John Wilmerding. New York: Harper and Row.
Wilkins, Thurman
 1966 *Thomas Moran: Artist of the Mountains.* Norman: University of Oklahoma Press.

George Smillie (1840–1921)

George Smillie was born in New York City in 1840. He was the son of engraver James Smillie and was the younger brother of landscape painter James David Smillie. Smillie was educated in private schools and began studying painting while still a young boy, first under his father and later with the landscape painter James McDougal Hart. By the time he was twenty-four, Smillie had a successful career as a landscape painter in the Hudson River School tradition and had been elected into the National Academy as an associate member. He exhibited yearly with the National Academy and with the American Water-color Society after he became a member of the latter in 1868. In 1871, Smillie made a sketching tour to the Rocky Mountains and Yosemite Valley; in 1874 he traveled to Flor-ida, also to study and sketch the scenery. He married Nellie Sheldon Jacobs, a genre painter, in 1881, and the two artists shared a studio with Smillie's older brother. Among Smillie's most important works are *Under the Pines of Yosemite* (1875) and *Sentinel Rock, Yosemite Valley*; the latter was shown at the National Academy's Centennial Exhibition in 1882. Smillie died in 1921.

St. Augustine, the city that so disappointed Thomas Moran, obviously fascinated George Smillie. He visited Florida in the late winter and spring of 1874, a few years before Moran, and his trip yielded a number of watercolors of St. Augustine. *Market and Bay, St. Augustine, Florida* (1874) is an industrious and observant portrayal of what must have been a focal meeting place, the market. The shell of the building still stands today. Tightly knit groups of animated people are gathered in conversation and at business. The scene is rendered in a somewhat provincial but realistic style which carefully delineates the struc-ture of the buildings, the gnarled trees, and the characters themselves. It also incorpo-rates the bay, the old lighthouse on Anastasia Island, and several sailing craft. A charm-ing period piece, this work portrays a simpler era.

C.J. and R.K.B.

Bibliography
Stebbins, Theodore E., Jr.
 1975 *The Life and Works of Martin Johnson Heade.* New Haven: Yale University Press.
Waters, Clara Erskine Clement, and Hutton, Laurence
 1969 *Artists of the Nineteenth Century and Their Works.* 7th Ed. New York: Arno Press.

George H. Smillie
Market and Bay, St. Augustine, Florida, 1874
Watercolor on paper, 7⁵/₈″ x 11³/₄″
Anonymous Collection

James Wells Champney (1843–1903)

James Wells Champney was born in Boston on July 16, 1843, the son of Benjamin Champney, a portrait and landscape painter. He studied drawing at the Lowell Institute in Boston and apprenticed as a wood engraver when he was sixteen. Although called ''Wells'' by his close friends and family, he signed his early works, ''Champ.'' He joined the 45th Massachusetts Volunteers at the start of the Civil War but was discharged after he contracted malaria. Champney taught drawing in Lexington, Massachusetts, for two years, then left for Europe in 1866. He studied in Paris and during the summer of 1867 worked under the genre painter Edouard Frère in Ecouen. Champney studied at the Royal Academy in Antwerp, Belgium, until 1869, when he returned to Paris to work again with Frère. He began his career as a genre artist—his subjects were usually scenes of country home life—with his first exhibition at the Paris Salon in 1869. Champney lived in Rome that winter, but the following summer, in 1870, he traveled to Nova Scotia on a sketching tour. Back in Boston that year, he opened a studio only to leave for Europe once again in the spring of 1871. In 1873 he and the journalist Edward King were sent by *Scribner's Monthly* on a journey through the southern states to record the region as it appeared almost ten years after the Civil War. Champney illustrated the articles, which were quite popular in the United States and England; later, the series was made into a two-volume work, *The Great South*.

Champney eloped with Elizabeth Williams in 1874, and the newlyweds traveled to France, then to Spain in May, 1875, where they stayed for three weeks in an encampment of the Carlist Rebellion. That year they returned to America, where Mrs. Champney wrote books and articles, many of which Champney illustrated while he also worked for the French magazine *L'illustration*. He became a professor of art at Smith College in 1877, traveled to South America on assignment for *Scribner's* in 1878, and, upon his return, taught at both Smith and the Hartford Society of Decorative Arts. Around 1880, Champney virtually stopped painting in oils and watercolors and began to produce pastel portraits. He was elected an associate member of the National Academy of Design in 1892 and died in New York City in an elevator accident in 1903.

The study that James Wells Champney and Edward King made of life in the South after the Civil War resulted in a work of nineteenth-century romantic hyperbole that is elevated, periodically, with objective reporting. Although *The Great South* is entertaining to read, Champney's illustrations—usually simple, atmospheric images—more eloquently capture the best of Florida's tropical beauty. His original brush drawings were made into wood block carvings and then printed for newspaper articles by another artist who visited and painted Florida, Thomas Moran. Later, Champney used washes and pencil to paint his Florida works based on the drawings. Champney and King culled their information about the South from the people they met while traveling there. Colonel Hart, whose orchard Champney illustrated in *Colonel Hart's Orange Grove* (n.d.), seemed to have been eager to supply the two journalists with the details of his successful business. King (1969: 402–403) wrote that ''Colonel Hart thinks his grove is worth at least $75,000,'' and, based on the prosperity of Hart's grove, which King noted bore ''an enormous crop,'' the journalist predicted that ''this culture of oranges will certainly become one of the prime industries of Florida.'' Champney's drawing of this grove documents the nearly obsolete use of manual labor to collect the oranges. He demonstrated Florida's lush vegetation by presenting the grove from a low viewpoint in order to emphasize the long rows of well-cultivated, fruit-laden trees.

Champney's two views of the Oklawaha River are particularly excellent studies of the

James Wells Champney
Colonel Hart's Orange Grove, n.d.
Wash, touched with white, on paper, 3$^{1}/_{4}$" x 5$^{5}/_{8}$"
Museum of Fine Arts, Boston
M. and M. Karolik Collection

James Wells Champney
Forest on the Oklawaha, n.d.
Wash and pencil on paper, 7¹/₄″ x 9³/₁₆″
M. and M. Karolik Collection

dense undergrowth that surrounds many Florida rivers. In both *Forest on the Oklawaha* (n.d.) and *On the Oklawaha, Florida* (n.d.), Champney depicts the shattered effect of sunlight as it filters through the thick brush to illuminate the trees and bushes in a patchwork pattern. A langorous air saturates the scene, and the twisting forms of the tree trunks and branches seem to stretch lazily up to the sun. In *Forest on the Oklawaha,* Champney recorded the sinuous line of two tree trunks twisted together in an exotic embrace. He left nothing out of these compositions; Florida's palm fronds, Spanish moss, cypress trees, and pools of water all were carefully observed. Champney even reproduced the slight haze that often settles in Florida forests in the humid early morning. King, despite his often one-sided views, wrote wittily about this river in his chapter, "Up the Oklawaha to Silver Spring." He advised that "the invalid from the North, anxious to escape not only from the trying climate which has increased his malady, but also the memories of the busy world to which he has been accustomed, could not do better than to drift up and down this remote and secluded stream, whose sylvan peace and perfect beauty will bring him the needed repose" (King 1969: 408). Florida, to the average American from the North at this time, represented a colorful, endlessly fascinating land. Champney's paint-

James Wells Champney
On the Oklawaha, Florida, n.d.
Wash and pencil on paper, 6³/₈" x 8¹/₄"
Museum of Fine Arts, Boston
M. and M. Karolik Collection

ings illustrated the unique and exciting qualities of the South and were further encouragement for Northerners to journey south and fully enjoy "the subtle moonlight, the perfect glory of the dying sun as he sinks below a horizon fringed with fantastic trees, the perfume faintly borne from the orange grove, the murmurous music of the waves along the inlets, and the mangrove-covered banks" of Florida (King 1969: 378).

C.J.

Bibliography
1962 *M. & M. Karolik Collection of American Water Colors & Drawings: 1800–1875,* vol. 1. Boston: Boston Museum of Fine Arts.
King, Edward
 1969 *The Great South,* vol. 2. New York: Burt Franklin.
Waters, Clara Erskine Clement, and Hutton, Laurence
 1969 *Artists of the Nineteenth Century and Their Works.* 7th Ed. New York: Arno Press.

Stephen J. Parrish (1846–1938)

Stephen J. Parrish, painter and etcher, was born on July 9, 1846, in Windsor, Vermont. He was the father of illustrator and painter Maxfield Parrish. Although little is known of his life, he seems to have had a late start on his artistic career. When he was thirty-one he began studying under a local artist and produced and exhibited his first etched plate two years later in 1879. According to an 1883 magazine article, Parrish first sketched his subject from nature, then adapted the pencil drawing as he worked in point and acid technique (Van Rensselaer 1883). He was a member of the London Royal Society of Painters and Etchers and the New York Etching Club. Parrish exhibited at the New York Etching Club and in Paris (1885), Liverpool, Vienna, Dresden, Philadelphia, and Boston. He died on May 15, 1938.

Although Stephen Parrish began his artistic career rather late in life as an etcher, he was able to transform himself into a fine painter. His later paintings show that he was clearly aware of the modern art scene, which had moved so drastically ahead of the American landscape tradition. Parrish was particularly interested in producing expressive skies, as well as in creating scenes that described the moods of nature. In *On the Miami River, Florida* (ca. 1920), the artist demonstrated his interest in illustrating the dynamic nature of the sky. The sky dominates the work, taking up the upper two-thirds of the canvas. The thick, swirling clouds obviously were not intended as purely realistic representations; instead, Parrish used them to express the vitality of natural phenomena. His energetic brushwork, with strokes applied in rapid succession so that they scatter in all directions, adds to the feeling of quick movement. The surprising splashes of bright pink and golden yellow, seemingly haphazardly placed among the light blue, white, and pearl gray of the sky and clouds, are evidence that Parrish had been looking at modern art. Directly below, the river reflects the sky, but again, not in the straightforward, realistic manner seen in the landscapes of artists only slightly older than Parrish. Here the sky's reflection is a kind of woven pattern of short strokes painted in vertical or horizontal parallel lines and overpainted with more short parallel lines always in the direction opposite to those beneath. Parrish had clearly learned that less can be more when a painting is executed with an eye for the overall effect. The foliage along the banks of the river was composed of many tiny dabs of paint, smudged as needed to create the illusion of the rustling leaves. To add highlights, especially in the water, Parrish dabbed on spots of strong pigments. Deep gray-blue, maroon, dark green, and burnt orange were applied in small strokes all over the painting. This work is an intriguing melange of the traditional landscape style and the modern style that allows color and brushwork techniques to play a part in creating the beauty of a painting.

C.J.

Bibliography
Falk, Peter Hastings, ed.
 1985 *Who Was Who in American Art.* Madison, Connecticut: Sound View Press.
Van Rensselaer, M. G.
 1883 "American Etchers." *Century Magazine,* vol. 25 (February): 483–99.

Stephen J. Parrish
On the Miami River, Florida, c. 1920
Oil on panel, 16" x 20"
Anonymous Florida Collection

Frank Hamilton Taylor (1846–1926)

Frank Hamilton Taylor enjoyed a varied career as artist, journalist, and publisher. He earned his reputation during an era that saw the great rise in popularity of such illustrated magazines as *Harper's Weekly Journal of Civilization*. His talent as an artist was complemented by his ability as a correspondent, qualities that his colleagues held in high regard (Gustke 1984).

Born in 1846, Frank Taylor was raised in New York State. At the age of twenty-two he was apprenticed to a lithography firm in Philadelphia, and went on to become the partner of an engraver in a printing and publishing business. Various guidebooks, maps, and illustrated records are among Taylor's publications. In 1876 the New York *Graphic* employed Taylor to illustrate the Centennial Exhibition held in Philadelphia. This was the first of numerous assignments that were instrumental in furthering Taylor's reputation as an illustrator. Working as a free-lance correspondent, Taylor wrote occasional articles for the *Public Ledger* and the *Times*, two Philadelphia newspapers.

In 1880, Taylor was assigned the prestigious job of special correspondent for *Harper's Weekly* to cover the three-month tour of former president Ulysses S. Grant through Florida, Cuba, and Mexico. He joined Grant's party in Fernandina, Florida, in January 1880, and as the group moved from St. Augustine to Ocala, journeyed down the St. Johns and Oklawaha rivers, and eventually sailed from Cedar Key to Key West and on to Cuba and Mexico, he recorded the various events through illustrations and special reports. Taylor's drawings, watercolors, and notes were sent to *Harper's*, where wood blocks were skillfully engraved, providing for the mass production in print of his images.

Taylor went on to other assignments, although the age of photography was soon to eclipse the role of art correspondent. Many years later, at the age of eighty, he reviewed his drawings, saved for him by *Harper's Weekly*, and reminisced, "How much they recall to me. How like a stately picturesque dream it now seems to me" (Gustke 1984: i). Taylor died in Philadelphia in 1926.

Two black and white brush drawings from Taylor's Florida scenes best exemplify the unspoiled beauty that Grant's party found. *A Florida Beach (Fernandina?)* (1880) captures General Grant (always identifiable in Taylor's illustrations as the man in the black stovepipe hat) in a contemplative moment as he gazes out to sea. The neat composition creates a comfortable space in which a thicket of brush is played against an infinite horizon of ocean and sky. Small waves break against the beach in winter, and it is easy to imagine Grant, lost in thought, enjoying the breeze rippling past him and the feeling of sand beneath his feet.

General Grant in Florida–A Trip on the Oklawaha (1880) is set in Florida's dense, jungle-like interior. Like James Wells Champney's version of the same subject, Taylor's drawing leaves little to the imagination. Even the small cypress knees are faithfully rendered (not so in the subsequent engraving; the engraver obviously was confused by the depiction of this unique element of nature). A feeling of torpor is induced by the overwhelming vegetation and the slick surface of the slack river in which boat and party are reflected. The stillness of the scene, in which even the exhaust of the boat's engine hangs in the air, creates a mood of lethargy, capturing the boat, the party, and the river forever in time.

R.K.B.

Bibliography

Gustke, Nancy L.
 1984 *"A Stately Picturesque Dream…" Scenes of Florida, Cuba, and Mexico in 1880*. Gainesville: University Presses of Florida.

Frank H. Taylor
A Florida Beach (Fernandina?), 1880
Black and white brush drawing, 6¹/₄″ x 9⁷/₈″
University Gallery, University of Florida

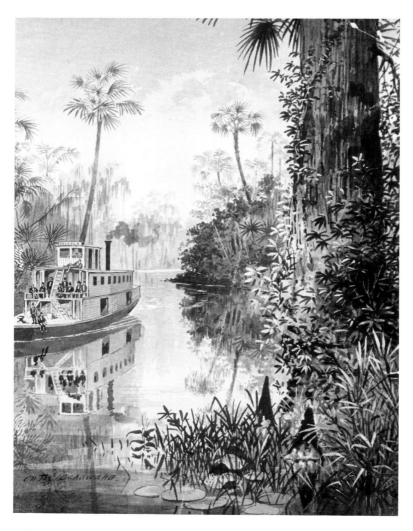

Frank H. Taylor
General Grant in Florida—A Trip on the Oklawaha, 1880
Black and white brush drawing, $12^5/8'' \times 9^5/8''$
University Gallery, University of Florida

George Herbert McCord (1849–1909)

George Herbert McCord, a landscape and marine painter, was born in Brooklyn, New York, on August 1, 1849. He studied art under Col. James Fairman in 1866, and perhaps for a time under Samuel F. B. Morse. Although McCord lived most of his life in Brooklyn and New York City, his sketching tours around the United States included visits to the Berkshires, New Jersey, New England, the Adirondacks, and Florida. He visited England for a lengthy stay in the 1890s and may have spent time in Italy in 1871–72. Beginning in 1869 with the Brooklyn Art Association (with whom he regularly showed until 1886), McCord exhibited throughout his career both in his native city and elsewhere. His works were shown at the Philadelphia Academy of Fine Arts, and from 1870 to 1900 he exhibited frequently at the National Academy of Design. He won a medal at the New Orleans Expo (1885) and received another prize at the St. Louis Expo (1904). McCord was a member of the American Watercolor Society and was elected an associate member of the National Academy of Design in 1880. Some of the artist's better known works include *The Cave of the Winds, Niagara, Twilight Reverie,* and *Sunnyside,* a painting of Washington Irving's home. McCord died on April 6, 1909.

George McCord's sublime Florida paintings recall Thomas Cole's description of the sky as "the soul of all scenery, in it are the fountains of light, and shade, and color. Whatever expression the sky takes, the features of the landscape are affected in unison" (Novak 1976: 86). McCord's *Florida Sunrise* (n.d.) is a dazzling representation of Cole's "liquid gold" sunset. An orange-yellow light permeates the scene, rising on the horizon in a magnificent cloud of such stunning intensity that its color touches nearly every object in the painting. This blast of glorious light glints on the water, tree trunks, and leaves of the bushes; it is so bright on the white birds that they almost become golden replicas of their living counterparts. Nevertheless, McCord maintained the integrity of the Florida landscape. His bright green lilypads float on the shining lake, the foreground bushes are touched with dashes of deep green, and the palm trees rise above the overwhelming light, their fronds remaining green and alive, all of which indicate that McCord ultimately wanted to depict a naturalistic scene. Like so many nineteenth-century artists, McCord was interested in the religious qualities of a beautiful landscape. Accordingly, he painted the light-filled lake as the water which in Christian symbolism served as "a medium poised between transparency and reflection" and in doing so "touch(s) upon central spiritual profundities that engaged the age" (Novak 1976: 95).

Another work by McCord, also called *Florida Sunrise* (n.d.), expresses a subtler manifestation of the rarified atmosphere of light in nature. The artist had moved into the realm of allusion and used broad brushstrokes to lay on paint in thick patches. Now, masses of pigment form a nearly abstract image that suggests a dark group of trees looming in the foreground and silhouetted by a brilliant glow of light behind. No longer are the elements in the work carefully painted in a realistic manner. Instead, McCord has produced a study of light, shadow, and color set within a framework of reality. The painting seems to be a montage of many landscapes, an icon that allows the viewer to create his own impressions and one that embodies the mysteries of nature in an eternally fresh image of primeval forest.

C.J.

Bibliography
Novak, Barbara
 1976 "On Divers Themes from Nature." *The Natural Paradise: Painting in America, 1800–1950,* edited by Kynaston McShine. New York: The Museum of Modern Art.

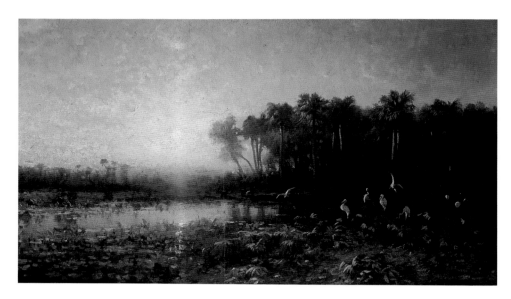

George Herbert McCord
Florida Sunrise, n.d.
Oil on canvas, 14" x 24"
Courtesy of Robert M. Hicklin, Jr., Inc., Spartanburg, South Carolina

George Herbert McCord
Florida Sunrise, n.d.
Oil on canvas, 6" x 12"
Anonymous Florida Collection

Louis Comfort Tiffany (1848–1933)

Louis Comfort Tiffany's art and his family's famous store, Tiffany & Company, known for its priceless jewels and art objects, have had a lasting impression on the American concept of style. Although Louis C. Tiffany is recognized as the creator of innovative stained glass compositions and other glass works, it is less well-known that he was also an accomplished painter. Tiffany was born on February 18, 1848, into a family whose wealth enabled him to make his first trip to Europe in November, 1865, while he was still quite young. During this five-month journey, Tiffany drew and painted with watercolors much of what he saw; the experience most likely helped him on his way to becoming an artist. He enrolled in the National Academy of Design in 1866 and at about the same time was privileged to begin study under George Inness, who took few students under his wing during his career. After a short stint with Inness, Tiffany exhibited his first work in 1867; he then went to Paris to study in the atelier of Leon Charles Adrien Bailly, a painter of genre and historical subjects, instead of at the Ecole des Beaux-Arts, as was customary for aspiring American artists. In 1869, Tiffany returned to New York and began to paint and exhibit landscapes. During the next decade, he traveled often to Europe and to North Africa, and these trips molded his style. The brilliant colors and light of Morocco, Algeria, Tunisia, and Egypt forever changed how Tiffany viewed his world; he began to exhibit his Eastern watercolors and oils in 1871 with much success.

Tiffany married his first wife Mary Woodbridge Goddard, who would bear him two daughters and a son, in 1872. In subsequent years, he became involved in numerous artistic enterprises such as founding several artists' societies, designing wallpaper and glass products, and redecorating the White House for President Chester A. Arthur. In 1882 the Tiffanys visited St. Augustine; this was probably the only time Tiffany spent in Florida, yet he recalled the landscape well enough to paint a Florida coastal scene three years later. Tiffany's wife died in 1884, and he remarried in 1886. He continued to travel and paint but in his later years grew increasingly busy with his glass works. He had a final painting exhibition in 1924 and died on January 17, 1933.

Architecture set in an atmospheric landscape is a frequent subject in Louis Comfort Tiffany's paintings. During his travels in Europe and North Africa, Tiffany developed his painting style, but it was the vivid light and unique architecture of the North African countries that most intrigued him. He painted the mosques and casbahs of this region and, intent on recording their appearance in their natural settings, usually included portrayals of the surrounding landscape and indigenous people. In *St. Augustine* (1885) the artist painted the Spanish-built Castillo de San Marcos as viewed from the nearby beach. Tiffany chose a long canvas to illustrate the length of the stone structure and placed the building closer to the top portion of the canvas to emphasize further the vastness of the fortress even when seen from a distance. This low viewpoint stresses the fort's commanding presence and indomitable appearance; the dark gray walls, topped by a watchtower, jut out into the ocean as symbols of challenge and protection. In contrast to this emblem of strength, the people in the foreground seem flimsy, an impression enhanced by the strong sea breeze that whips their clothes back. Tiffany's somber palette of earth tones and shades of gray, together with the spreading mass of dark clouds in the upper right corner, highlight the comtemplative nature of the scene. Also contributing to the meditative tone of the work are the two figures on the otherwise deserted beach, who seem transfixed by the continual movement of the ocean and wind. Tiffany had as keen a sense of design, seen in the careful balance between lights and darks, verticals and horizontals, as he did for appropriate atmosphere. For other artists who painted Florida, the overriding creative source was nature, which they felt was still in a pure state that hinted

Louis Comfort Tiffany
St. Augustine, 1885
Oil on canvas, 18½″ x 38″
Courtesy of Elliott Galleries, New York City

at an ancient past before man was created; they felt a sense of ''primordial time'' that could only be evoked in paintings of unsullied forests, rivers, and wildlife (Novak 1976: 89). For Tiffany, this St. Augustine fortress, built in the oldest city in America, represented another kind of history, a remnant from a bygone era that he wished to recreate.

C.J.

Bibliography
Novak, Barbara
　　1976 ''On Divers Themes from Nature.'' *The Natural Paradise: Painting in America, 1800–1950,* edited by Kynaston McShine. New York: The Museum of Modern Art.
Reynolds, Gary A.
　　1979 *Louis Comfort Tiffany: The Paintings.* New York: Grey Art Gallery and Study Center, New York University.

George Cope (1855–1929)

Quaker artist George Cope was born on February 4, 1855, in Chester County, Pennsylvania. He grew up on a farm and, as an avid outdoorsman, became highly skilled in hunting and fishing. His early love of nature and his parents' interest in painting and poetry gave Cope his first incentives to become a painter. Cope revealed in a 1920s interview with the *Daily Local News* that his "first inclination was to be a caricaturist," but his Quaker father quickly discouraged this interest in making "a game of people" (Sill 1978: 8–9). Cope also painted seascapes, still lifes, and landscapes during these formative years. Although no records attest to it, he may have studied at the Pennsylvania Academy of Fine Arts in Philadelphia from 1872 to 1876, a time when Thomas Eakins taught there. Cope met the landscape painter Herman Herzog in 1876 at the Philadelphia Centennial and began to study with him, learning oil painting techniques; the two artists often took sketching tours together to the Pocono Mountains and around West Chester. In the same year, Cope traveled to the West, where he painted many landscapes of the region; he made a second journey west in 1879 with his father. He exhibited his first work in 1878 and opened a studio in West Chester in 1880, where he also taught oil painting. A year later he established another studio in Philadelphia. He married Theodosia Blair in 1883 and in 1884 advertised as an oil painting restorer. He supplemented his income by also repairing frames and painting glass clock faces. In the mid-1800s, Cope began to paint still lifes as well as landscapes, usually choosing dead game as his subject. Around 1887, possibly spurred on by William Harnett's *trompe l'oeil* series *After the Hunt*, Cope began to work in this popular and lucrative genre. In 1890, Cope was granted patents from the United States, Italy, Great Britain, and France for his design for a canvas stretching device. France also elected him an honorary member of the Inventor's League. A commission to paint a Florida landscape for a land development company took him south in 1891, and a newspaper announcement noted that the landscape was to be exhibited at the Columbian Exposition in Chicago. Years later, Cope would produce several sketches and oil paintings of Florida. From 1896 to 1900 Cope was busy painting landscapes and animal portraits, never portraits of people, but by 1899 his commissions had lessened and he was forced to teach drawing and painting more often in order to support his family. In 1900 he returned to Florida, where he visited relatives and made sketches for a series of small landscapes he would paint in the last years of his life. By the turn of the century, Cope began to paint mostly small still lifes in response to the wishes of his patrons. In 1913 he met Dr. Henry Pleasants, Jr., who collected a large number of Cope's late works, but the painter remained somewhat impoverished. Cope's last exhibition was probably in 1927; he died in 1929.

Although Cope's illusionistic still lifes, primarily of dead game and hunting equipment painted in the *trompe l'oeil* tradition, won him praise and financial reward during his most successful years of the 1890s, he had always been a landscape painter and returned to this genre periodically. Cope was early influenced by Herman Herzog's more painterly style in the Barbizon School tradition, but he seemed to take greater pleasure in recording detail with meticulous accuracy. Cope maintained his customary emphasis on realism in his landscapes. Yet in all of these works he used a softer, looser style to depict trees, bushes, and grass, painting with an impressionistic suggestion of the foliage rather than rendering every detail with the painstaking exactitude of his hard-edge style. The idyllic *Florida Scene* (1915) illustrates George Cope's various artistic abilities and interests. The tightly painted lilypads in the foreground and the crisp lines of the oak trees draped with ghostly swatches of moss in the middle ground illustrate Cope's interest in the realistic representation of nature. The ordered procession of lilypads divides the canvas in half

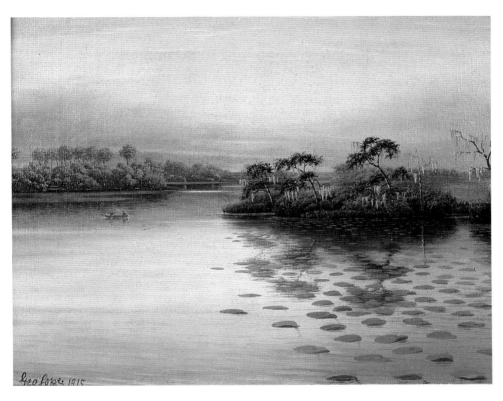

George Cope
Florida Scene, 1915
Oil on canvas, 11″ x 14″
Anonymous Florida Collection

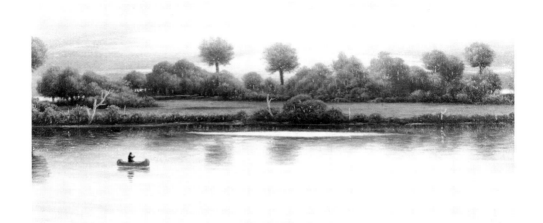

George Cope
Florida Landscape, Sunny, 1913
Oil on canvas, 6″ x 10″
The William Cope Family

and draws the viewer's eyes directly back to the grassy islet that cuts off the rest of the view of the lake. Immediately, attention is focused on the left middle ground where two people paddle a canoe, enjoying the day in this lovely natural setting. Brilliant shades of pink, turquoise, and lavender enhance the sky and clouds, which are reflected in the clear lake water. Cope's painting is his personal vision of the natural paradise he found in Florida.

In *Florida Landscape, Sunny* (1913) and *Florida Landscape, Cloudy* (1914), Cope chose to bring the scenes closer, which, along with the tiny size of the canvases, creates a feeling of intimacy, even privacy. In *Sunny,* a lone person, completely at ease in his natural environment, paddles a canoe and gazes at the shore. Cope seems to have painted the ideal human, at one with the world, enjoying the land with no intention of altering or destroying it. The water is perfectly still, and the canoe barely makes a ripple as it smoothly glides along. *Cloudy* reiterates this harmonic theme. The scene is pulled even closer in this work, enclosing the viewer within the space. A sailboat at the right tilts slightly in the direction of the bird in flight at the upper left to express the rapport between man and nature as well as to balance each side of the painting. The ruined dock at the edge of the shore and the slight ripple in the water suggest a slight agitation, possibly due to man's intrusion in this Eden-like setting. Yet Cope maintained an overall tranquility closely related to the *Sunny* version, as if to illustrate that all remains serene in this halcyon part of the world. Cope loved the outdoors, and the series of tiny Florida landscapes that he painted during the last decade of his life reflects his genuine appreciation for the quiet ambience of this then largely unpopulated state.

C.J.

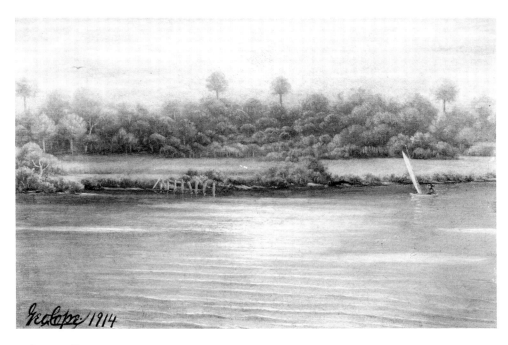

George Cope
Florida Landscape, Cloudy, 1914
Oil on canvas, 6" x 10"
The William Cope Family

Bibliography
Sill, Gertrude Grace
1978 *George Cope, 1855–1929.* Chadds Ford, Pennsylvania: Brandywine Conservancy, Inc.

John Singer Sargent (1856–1925)

John Singer Sargent, although included among American artists, cannot be labeled with one nationality. He was born in Florence, Italy, in 1856 to American parents who lived and traveled abroad. He was educated in Germany and Italy and did not visit the United States until he was twenty years old. At age fourteen, Sargent entered the Accademia delle Belle Arti in Florence, where he attended classes intermittently until 1873. When he was eighteen, he went to Paris to study under Carolus-Duran, a famous French portrait painter, and to take drawing classes at the Ecole des Beaux-Arts. During these years, Sargent also traveled in Europe, stopping in Venice, where he was encouraged by Whistler. In 1879 and 1880, Sargent went to Spain, Holland, and Belgium to study the works of Velasquez and Franz Hals. He turned to portraiture by 1881 and established his reputation in Paris, Boston, and New York, as well as in London, where he eventually made his permanent home in 1886. Although Sargent preferred life overseas, the numerous commissions he received from wealthy Americans caused him to return periodically to the United States for lengthy visits. Sargent was commissioned to paint murals in the Boston Public Library, Boston's Museum of Fine Arts, and the Widener Library at Harvard University, projects that he worked on from 1890 to 1925. During one of these working trips in 1917, Sargent visited John D. Rockefeller at his winter home in Ormond Beach, Florida, then went on to stay with Charles Deering in Miami some weeks later. By this time, Sargent seldom painted oil portraits, although he had been persuaded to paint Rockefeller's, and had become more interested in landscape painting and recording the effects of sunlight. These are themes he explored with watercolors and which can be observed in his Florida paintings. Sargent died in London in 1925.

Throughout his career, John Singer Sargent painted an enormous range of subjects in both oil paint and watercolor. During a three-month sojourn in Florida in 1917, he continued his search for inspiring new material, often choosing subjects of striking contrast to his formal portraits of wealthy society denizens. Sargent's watercolors, especially those of Florida and Venice, Italy, represent the artist at his most informal and exciting. In his thirty-six Florida works, Sargent captured the light, atmosphere, and landscape that are peculiar to this state but depicted these elements with emphasis on intriguing juxtapositions, finely tuned color gradations, and the formal qualities of line, shape, and perspective. In *Palm Thicket, Vizcaya* (1917) Sargent concentrates on a dense portion of tropical foliage, carefully delineating several palm fronds, and then creating an explosive background into which they merge. He captures the exact nature of the Florida light, painting myriad patterns and colors that are fractured and brilliantly highlighted against an abstract background. The closely cropped composition and lack of depth illustrate his tendency to depict the "random disorder of landscape scenes" (Strickler 1987: 130), thus confronting the viewer with a work of complex pictorial interest. The palm fronds recede in depth yet maintain the flat forms and abstract shapes of modern art contemporary with Sargent's work. Sargent is once again revealed as a masterful colorist. In *Palm Thicket, Vizcaya* his jewel-like colors enrich the scene and are particularly effective in their layered application. Some shades are applied to dampened areas of the sheet, while others are loaded on the brush and stroked with an apparent freedom that belies the care and precision the artist must have exerted in order to achieve the brilliant subtleties of color range. Throughout, the vitality of this watercolor reveals itself as both a naturalistic landscape and an exploration of artistic intent.

C.J.

John Singer Sargent
Palm Thicket, Vizcaya, 1917
Watercolor on paper, 13³/₄″ x 21″
Private Collection, New York

Bibliography

Silver, Janet G., ed.
 1983 *A New World: Masterpieces of American Painting, 1760–1920.* Boston: Boston Museum of Fine Arts.

Strickler, Susan E., ed.
 1987 *American Traditions in Watercolor: The Worcester Art Museum Collection.* New York: Abbeville Press.

Waters, Clara Erskine Clement, and Hutton, Laurence
 1969 *Artists of the Nineteenth Century and Their Works.* 7th Ed. New York: Arno Press.

Frank Weston Benson (1862–1951)

Frank Weston Benson was born on March 24, 1862, in Salem, Massachusetts. Both versatile and productive, he was, at the height of his career, one of Boston's leading artists. Benson studied at the Boston Museum of Fine Arts School from 1880 to 1883 and then spent two years studying with Gustave Boulanger and Jules Lefebvre at the Academie Julian. The artist produced oil paintings, watercolors, etchings, and drypoints of interior scenes, still lifes, formal portraits, landscapes with figures, wild birds, and sporting subjects. He exhibited at the National Academy of Design in Boston in 1889 and during the next decade began painting in the Impressionist style. In 1897, Benson helped found the Ten American Painters, an Impressionist group that sought to add a distinctive American flavor to the French art movement.

Benson won numerous awards and prizes throughout his career, including Third Hallgarten prize for his 1889 exhibition, a silver medal at the Paris Expo of 1900, two gold medals at the St. Louis Expo of 1904, and the Palmer Medal and Prize from the Art Institute of Chicago in 1909. During these successful years, he became well-known as a painter and teacher at his alma mater, the Boston School of Fine Arts.

In 1912, Benson began experimenting with etching and drypoint, often producing naturalistic depictions of ducks. He continued to work in the graphic arts as well as in oils and watercolors throughout his long career. In 1919 he was awarded the first W. A. Clarke Prize and the Corcoran Gold Medal and the next year was given a retrospective exhibition at the Corcoran Gallery of Art in Washington, D.C. In 1945 a major retrospective exhibition of his graphic works was mounted at the Guy Mayer Gallery in New York City. Benson died on November 15, 1951.

Frank Benson, like George Cope, was an avid outdoorsman whose paintings reflected his love for wildlife. In his watercolors of birds, Benson created an individual style that combined the Impressionists' use of painterly brushstrokes and less attention to minute detail with a thorough observation of the nature of his subjects. Benson devised simple yet striking compositions that depended upon freer drawing and emphasized the spontaneity of the scene. His etchings, a medium he began to use seriously in 1912, developed from this watercolor style. In the abstraction of the compositional design and in the artist's awareness of the realism of both subject and setting, Benson's bird watercolors resemble Japanese ink paintings. He often chose a black and gray palette in which to paint his birds, a technique probably inspired by Japanese eighteenth-century ink paintings of animals and birds from the Edo period (Strickler 1987: 156). The Museum of Fine Arts, Boston, bought a large collection of these Japanese works in 1911, and Benson most likely saw these, although Winslow Homer's grisaille watercolors may also have influenced him to adopt a monochrome palette (Strickler 1987: 156). In the ink wash *Florida Keys* (c. 1915), Benson demonstrates his knowledge of ornithology. The pelicans soar through the air, startlingly naturalistic, yet produced with a technique that minimizes excess detail. A few strokes of the brush and the birds come to life. Benson was aware of the beauty in the natural pattern of birds in flight, but he was also aware that he could heighten the effect of his paintings by adjusting this natural design to better fit his artistry. Benson said that "composition is about nine-tenths of a picture" (Chamberlain 1938: 177), and his careful placement of diagonals and strong contrasts of dark and light to create exciting designs seems to prove that he was correct. The descending diagonal of the bushes that frame the foreground is subtly balanced by the tiny row of trees on an island in the distance, all of which are painted with the same rapid and broad brushwork

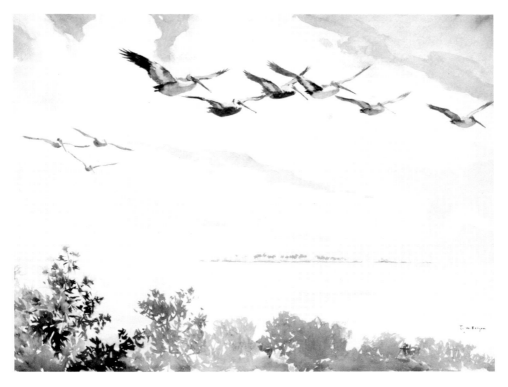

Frank W. Benson
Florida Keys, c. 1915
Ink wash on paper, 20″ x 27″
Anonymous Florida Collection

as the birds above. Benson's *Florida Keys* is both a graceful, evocative representation of birds in their natural state and a carefully composed vision of balance and ''fragile equilibrium'' (Chamberlain 1938: 179).

C.J.

Bibliography
Chamberlain, Samuel
 1938 ''Frank W. Benson—The Etcher.'' *Print Collector's Quarterly,* vol. 25 (April).
Strickler, Susan E., ed.
 1987 *American Traditions in Watercolor: The Worcester Art Museum Collection.* New York: Abbeville Press.
Young, William, ed.
 1968 *A Dictionary of American Artists, Sculptors, and Engravers.* Cambridge, Mass.: William Young and Co.

Henry Salem Hubbell (1869–1949)

Henry Salem Hubbell was born in Paola, Kansas, on December 25, 1869. When he was sixteen, he began to work as a scene painter in Garden City, Kansas, but soon moved to Chicago where he painted street signs and billboards and created advertisements. One of his billboard slogans, "Just Like Mother Used to Make," for Nonesuch Mincemeat won a prize and continued to be used into the twentieth century. From 1887 to 1897, Hubbell studied at the Chicago Art Institute, and during this time he met and married Nellie Rose Strong. He worked for a time as a book illustrator and magazine advertisement designer in Chicago, then moved to Springfield, Illinois, where he was employed as an illustrator for *Woman's Home Companion*. In 1898 the family, supported by a loan from an encouraging friend, left for Paris, where they would live intermittently for the next twelve years. Hubbell studied with Jean Paul Laurens, a historical painter, and Louis Joseph Raphael Collin, a portrait and figurative painter who worked in both the impressionistic style and the neoclassical manner. Hubbell developed an interest in genre subjects, but his talents led him to specialize in portrait painting. In 1901 he studied under James Abbot MacNeill Whistler, who hoped to train Hubbell as his assistant on extensive projects. However, that year, unwilling to give up his artistic individuality, Hubbell moved to Madrid for eight months in order to study the works of Velasquez and other painters in the Prado Museum. He returned to France and became friends with American Impressionists Robert Vonnoh and Carl Frieseke. During a brief visit to the United States in 1904, Hubbell turned to portraiture as his principal subject. He and his family lived in France for the next six years and at one point were neighbors of Claude Monet. In 1912 they returned to America and lived in New York City and Silvermine, Connecticut; from 1918 to 1921, Hubbell was the director of the School of Painting and Decoration at the Carnegie Institute of Technology. During this time, he developed his spontaneous one-day portraits; in these paintings, which were somewhat influenced by the Ashcan School, thick paint was applied quickly to add energy and vigor. In 1924 the Hubbells moved to Miami Beach, where he became an important community leader. The artist was a founding member of the University Board of Regents, first president of the Miami Civic Theatre (later moved to the University of Miami campus and renamed the Ring Theatre), and president of the Florida Society of the Arts and Sciences. Hubbell was in Washington, D.C., in 1934–36 on commission to paint portraits of fifteen past secretaries of the interior and President Franklin D. Roosevelt. He continued to create portraits of his friends and family as well as community leaders in Miami during his later years. Hubbell died on January 9, 1949.

Henry Salem Hubbell's years in Miami were filled with commissions to paint the portraits of many civic leaders. He returned to his earlier impressionist style in fulfilling these contracts yet retained much of the style he had developed for his one-day portraits. A painting of his wife, *Rose Strong Hubbell* (c. 1926), displays the quick brushstrokes and thick application of paint characteristic of the artist's one-day portraits. However, the misty quality, pleasant garden setting, and air of luxurious contentment relate also to the lushly painted figure works of such Impressionists as Monet and Renoir. Hubbell's use of short, rapid dabs of different colored paint is another connection to the work of Monet. And perhaps Hubbell's earlier influences still had an effect on his painting at this time. For instance, Whistler's interest in evoking the mood of the portrait sitter is evident in Hubbell's personal portrayal of his beloved wife. She is painted lovingly with softened edges, yet her cheerful personality shines through despite her placement in the cooler, shaded area of the lawn setting. She sits comfortably in a chaise lounge, dressed in fine clothes and jewelry, with her walking stick held elegantly and prominently in her left hand. Everything about her position and attitude, from the way her right hand gently

Henry Salem Hubbell
Portrait of Rose Strong Hubbell, c. 1926
Oil on canvas, 56" x 67"
Lowe Art Museum, University of Miami, Miami, Florida
Bequest of Henry Salem Hubbell, 1949

grasps the arm of the chaise, to her clear, steady gaze straight into the viewer's eyes, expresses this woman's strong character and quiet confidence. Velasquez's influence can be discerned in Hubbell's rendering of tiny, beautiful detail in the woven pattern of the chaise, the walking stick's golden handle and silken cord, and the jewels, as well as in the carefully painted details in the brilliantly sunlit background—the stone garden bench, foliage, and wall sculpture—which forms another tiny painting within the large one. Hubbell's evocative details of the setting and sitter render an accurate description of high society life in the tropical and Spanish-influenced beauty of Miami in the twenties and thirties.

C.J.

Bibliography
Thompson, Paul E., ed.
 1975 *Henry Salem Hubbell: A Retrospective.* Coral Gables, Florida: Lowe Art Museum.

Granville Perkins
Sunset on the Oklawaha, c. 1892
Watercolor on paper, 23″ x 15¼″
Anonymous Florida Collection

Granville Perkins (1830–1895)

Granville Perkins, illustrator and painter, was born in Baltimore, Maryland, on October 16, 1830. He studied in Philadelphia with James Hamilton, a marine and landscape artist. Perkins was a member of the American Watercolor Society and exhibited at the National Academy of Design throughout 1862–89 and at the Pennsylvania Academy of Fine Arts in 1856. He was also an illustrator for magazines such as *Harper's* and *Leslie's.* Perkins lived in New York City for most of his life, but he traveled often during his career, working in Baltimore, Richmond, Florida, Cuba, and Philadelphia. He died on April 18, 1895.

Sunset on the Oklawaha (c. 1892), a fiery, animated watercolor, captures an eternal moment in an expressive, romantic manner. Perkins has chosen to depict the Oklawaha River as a primordial jungle, bursting with exotic light that emanates from the setting sun. The atmosphere swirls and dances throughout the composition, disguising space and merging sky and river into one rhythmic flow. The effect is heightened by Perkins's limited use of color: the deep crimson highlighted with yellow enhances his spectacular and mystical vision. In this portrayal, compared with earlier scenes of the Oklawaha by James Wells Champney and Frank Taylor, the river has undergone a metamorphosis, from the calm and serene to the wild and primeval. Obviously moved by the intense beauty of a fleeting moment, Perkins created a fitting tribute.

C.J. and R.K.B.

Bibliography
1965 *Mantle Fielding's Dictionary of American Painters, Sculptors, and Engravers.* Addendum compiled by James F. Carr. New York: James F. Carr.

University Presses of Florida
15 Northwest 15th Street
Gainesville, Florida 32603

4 247PT2 097
 90 3 BR 4052